IMAGES
of America

OHEKA CASTLE

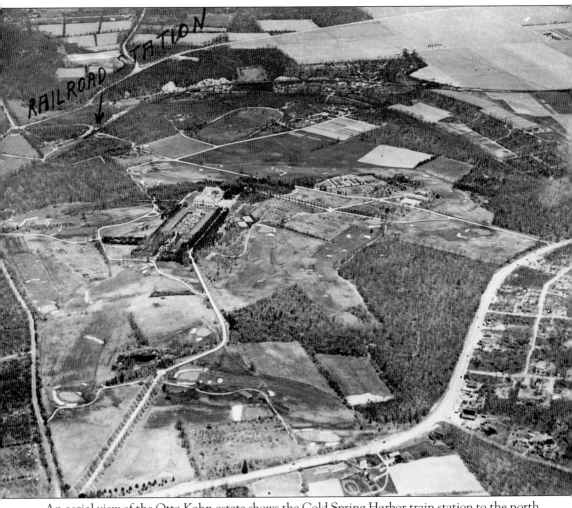

An aerial view of the Otto Kahn estate shows the Cold Spring Harbor train station to the north and Jericho Turnpike to the south around 1940. (Courtesy of OHEKA Castle Hotel & Estate.)

ON THE COVER: The west side of OHEKA Castle, facing the formal gardens, is pictured here around 1930. (Courtesy of OHEKA Castle Hotel & Estate.)

IMAGES
of America
OHEKA CASTLE

Joan Cergol and Ellen Schaffer
Foreword by Nelson DeMille

ARCADIA
PUBLISHING

Published by Arcadia Publishing
Charleston, South Carolina

Printed in the United States of America

Library of Congress Control Number: 2011944118

For all general information, please contact Arcadia Publishing:
Telephone 843-853-2070
Fax 843-853-0044
E-mail sales@arcadiapublishing.com
For customer service and orders:
Toll-Free 1-888-313-2665

Visit us on the Internet at www.arcadiapublishing.com

We dedicate this book to our families: Ryan, Dan, Emily, Kristina, and especially Greg, who, over the years, have enthusiastically supported our efforts to tell OHEKA's story.

CONTENTS

FOREWORD

OHEKA *Castle* is far more than the story of one of the largest private residences in America; it is also a fascinating biography of its builder and owner, Otto Kahn, one of the wealthiest men in America at that time. This book, which reads like an historical novel or an old-fashioned family saga, tells the engrossing history of the times in which Kahn lived—the Gilded Age, spanning the period from the end of the 19th century to World War I and into the Roaring Twenties and the Great Depression. The authors then take us on an impressively researched and well-written journey through World War II and into the present. The story of OHEKA Castle in many ways parallels the trials, tribulations, and fortunes of the nation during this tumultuous period in our history.

OHEKA Castle is located on what is known as the Gold Coast of Long Island, New York. As a native Long Islander, I grew up hearing the stories of the fabled Gold Coast as it existed in those fabulous eras of the Gilded Age and the Roaring Twenties, also known as the Jazz Age. I read *The Great Gatsby* many times, and I explored the ruins of many of the legendary mansions, visited the great estates that have been converted into museums, parks, and public institutions, and now and then, I'd be invited to the mansions that remained in private hands.

I was inspired by the remnants of this nearly vanished world to write a Gatsbyesque novel, which I titled *The Gold Coast*. In my novel, I make reference to the old Gold Coast estates and to the Long Island families who lived on them, such as the Vanderbilts, Posts, Pratts, Whitneys, Guests, Guggenheims, and the dozens of other rich and famous families whose wealth and power were unequaled in the history of America and the world.

One of my references in *The Gold Coast* was to Otto Kahn and OHEKA Castle, though at the time I had never actually been to OHEKA and had only read about it and seen photographs in books and magazines. The reference to Kahn and OHEKA in my novel had to do with the Kahn family's lavish Easter parties and to the Easter egg hunt, which consisted of golden eggs that each held a thousand dollar bill—a fortune in those days. This seemed to me an extravagant way to celebrate Easter, but it also represented the excesses of the Roaring Twenties, and it was a perfect illustration of what I was trying to convey in *The Gold Coast*.

That legendary period of lavish parties, Prohibition, and easy money ended on October 29, 1929, when the stock market crashed, and by 1939, OHEKA Castle had ceased to be the Kahn family residence.

The years of misuse and neglect are well chronicled in this book, so I will jump ahead to 1984, when my good friend Gary Melius made the decision to buy OHEKA. I quote here from chapter six: "In a daring—and a financially risky move—on August 14, 1984, Gary Melius shelled out $1.5 million to purchase the ruinous shell of what once was known as 'the finest country house in America.' The toughest and most expensive part of the project lay ahead: restoring his new castle to its former glory. The restoration would take years and would require the work of countless, highly skilled craftsmen." I, like many other Long Islanders, thought that Gary had taken leave of his senses. But Gary was (and is) an optimist and, more importantly, a visionary.

By the time I was writing *The Gold Coast* in 1989, Gary had owned the castle for five years and was still working on 127 rooms and 109,000 square feet of interior space. Time, weather, theft, neglect, and vandalism had seriously damaged the structure, and when Gary took possession of the castle, it had no working electricity, plumbing, or heating. But by the time I actually visited in the early 1990s, I would see what Gary Melius saw 10 years earlier—the great house was coming alive and a piece of American history had been preserved for future generations.

Let me not give away too much of this inspiring story, but skip ahead to May 2007. I am getting married in a small country church on Long Island, St. John's, in Cold Spring Harbor. My bride, Sandy, and I with our wedding party and 20 or so friends make the short drive to OHEKA Castle after the ceremony.

It is a beautiful day, and as we approach OHEKA Castle, the immense, fairy tale structure rises, dreamlike, into the perfect blue sky. We could be in France or Italy, or we could have been transported in time, back to the waning days of the Gilded Age or the riotous 1920s.

We drive into the cobblestone courtyard and are escorted through the grand foyer, up a sweeping staircase, and into the heart of the fully restored castle.

Gary has reserved a "small" private room for us, which easily accommodates our entire party, and there we have cocktails and wander out to the grass terrace. Later, we sit at a long table for our wedding dinner.

The word "perfect" can only partly describe the setting, the service, and the food; it is more like an otherworldly experience—a journey into a time and place that no longer exists beyond the walls of OHEKA Castle.

If rooms could speak (and they do in this book), you would hear in OHEKA, as I did that night, the voices of 100 years of American history.

Otto Kahn and Gary Melius are the bookends of this story—men of boldness, vision, and optimism in America. This is the story of their house and the century that separated them in time, but brought them together in spirit.

<div style="text-align: right">

—Nelson DeMille
Long Island, New York
2012

</div>

INTRODUCTION

Welcome to the story of OHEKA Castle, a premier entertainment venue and the largest restored home in America. Completed in 1919 by banker and patron of the arts Otto Kahn, OHEKA Castle towers majestically above the Cold Spring Hills neighborhood in Huntington, New York. From the moment the 109,000 square-foot edifice took its place on Long Island, OHEKA became the largest private home ever built in New York and the second largest in America.

At twice the size of the White House, OHEKA was constructed as the country house of a legendary New Yorker whose lifestyle reflected the excesses of the Roaring Twenties. Its subsequent uses mirrored important eras in American history. Following the Great Depression, New York City mayor Fiorello La Guardia battled Long Island politicians to transform it into a retreat for sanitation workers. Next, merchant marines occupied it as a World War II radio-operator training station. Then, a military school adapted it for educational purposes, sending many of its cadets to the Korean and Vietnam Wars. Falling enrollments amid 1970s antiwar sentiments forced the school's closing. By the 1980s, OHEKA had fallen into ruin and surrounding residents became frantic to save it and their neighborhood. Finally, a Long Island developer fell in love with it and risked millions on a bold plan to restore its grandeur. With thousands of residents at his side, the developer, Gary Melius, realized his dream, returning OHEKA to its former glory.

But how has this American treasure survived? Why didn't it suffer the fate of the thousands of mansions that have been lost? The answers lie in the stories of those who were called to action to fight for OHEKA's survival. We were fortunate to be among them. Through our shared experience, we discovered a recurring theme and passion for the castle that links millions of people who have experienced it in the past and those who discover it today.

This is a true American fairy tale offering intrigue, struggle, and near demise, ending with a dramatic and heroic rescue. In sharing OHEKA Castle's story, we tell a tale of victory for those who believe historic structures should and can be saved for future generations. By documenting this successful experience in historic preservation, we hope to educate and inspire others to attain their own hopes and dreams of saving that "big old house" down the road.

One

COLD SPRING HARBOR
1919–1939

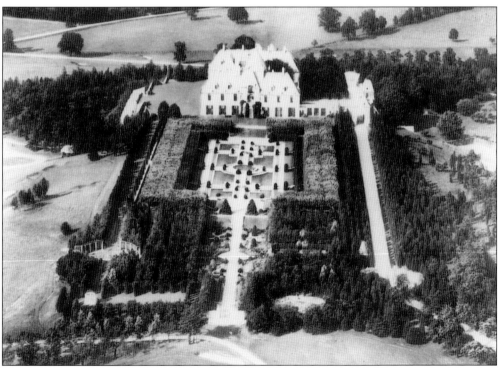

OHEKA Castle, completed in 1919, was the weekend retreat and summer home of one of the most celebrated financiers in American banking history, Otto Hermann Kahn. Born on February 21, 1867, in Mannheim, Germany, Otto Kahn was directed at an early age to a career in finance by his father, Bernhard Kahn, a banker who opened banking houses in two German cities. (Courtesy of Huntington Historical Society.)

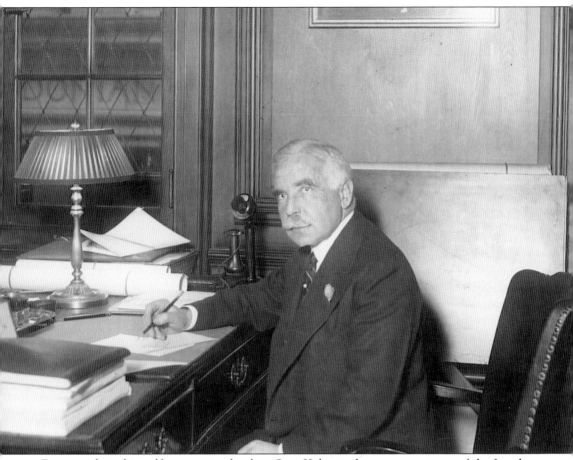

Distinguishing himself as a master banker, Otto Kahn took over as manager of the London branch of Deutsche Bank at the remarkable young age of 20. The burgeoning capitalist quickly fell in love with his new surroundings. Planning to stay in London indefinitely, Kahn became a naturalized British subject. In 1893, only six years later, Otto Kahn was successfully lured to New York in the hope of advancing his career. Edgar Speyer, a partner at Speyer & Company, offered him a position at the German-Jewish international banking house. Once again, his decision to move proved fateful. Just three years later, in 1896, a marriage was arranged between Otto Kahn and Addie Wolff. The daughter of prominent banker Abraham Wolff, Addie brought great wealth and higher social status to the marriage. After a yearlong European honeymoon, Otto and Addie Kahn returned to America to settle into married life. (Courtesy of Anne Baugh Minnehan.)

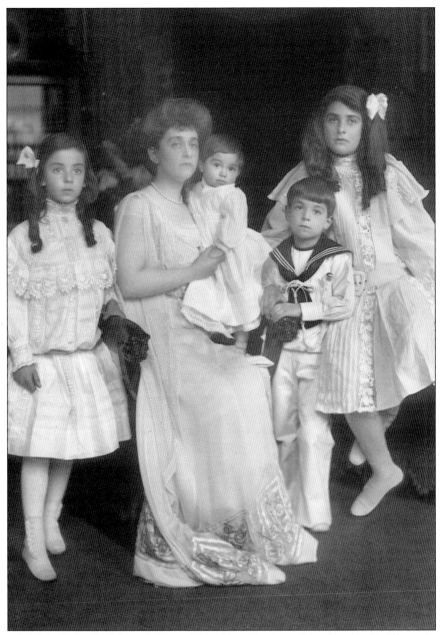

Otto and Addie Kahn had four children. The eldest daughter, Maud Emily Wolff, was born on July 23, 1897, followed by Margaret Dorothy Wolff on July 4, 1901. The Kahns welcomed their eldest son, Gilbert Wolff, on July 18, 1903, with Roger Wolff arriving five years later on October 19, 1907. The children, all baptized in Addie's Episcopalian faith, ranged in age from 12 to 22 the year the Kahns first summered at Cold Spring Harbor. A German-born New Yorker, Kahn was known for his immaculate dress. He was often photographed in a dapper double-breasted suit with a hat and walking cane. Other images captured him emerging from a Rolls Royce wearing a silk top hat and a satin-lined cape draped over his fine evening suit. His speech, accented with German and British, reflected both his birthplace in Germany and the time he spent abroad in London. (Courtesy of John Barry Ryan II.)

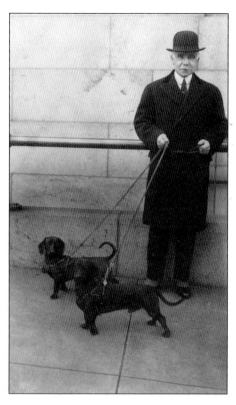

In the photograph at left, Kahn walks his dachshunds just outside his New York City mansion at 1100 Fifth Avenue and Ninety-first Street. Thomas Edison considered Kahn one of the most distinguished men in the world, and Will Rogers called him "The King of New York." Addie Kahn was born into banking royalty. She was a suitable match for Kahn, sharing many of the same interests. She was largely responsible for the acquisition of the couple's extensive art collection. (Left, courtesy of Anne Baugh Minnehan; below, courtesy of Huntington Historical Society.)

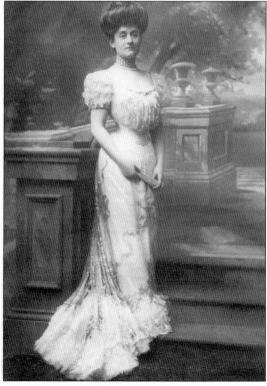

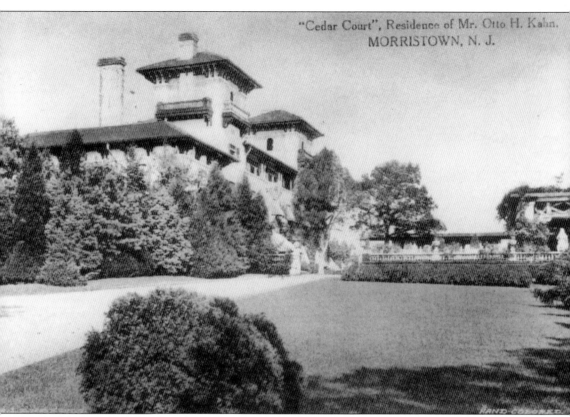

"Cedar Court", Residence of Mr. Otto H. Kahn.
MORRISTOWN, N. J.

"Cedar Court," the Kahns' home in Morristown, New Jersey, was destroyed by fire in 1914. Because of this, the couple began looking for a new summer residence. Kahn's search led him to Cold Spring Harbor, New York. The family referred to the 109,000 square-foot chateau as "Cold Spring Harbor." Later, the mansion came to be known as OHEKA: O for Otto, HE for Hermann and KA for Kahn. On Long Island, Kahn sought two things. First, he wished to escape the harsh rejection he and Addie suffered while living in Morristown, where he was barred from local social and golf clubs because he was Jewish. Second, he wanted to replicate all of the amenities he and Addie had enjoyed in Morristown—a stately home high on a hill—with pools, fountains, bridle paths, and an 18-hole golf course on hundreds of rolling acres. (Courtesy of OHEKA Castle Hotel & Estate.)

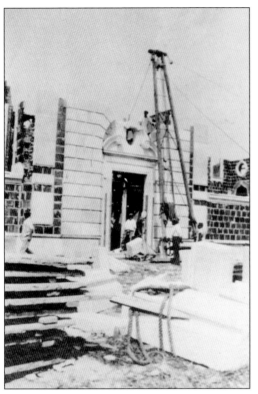

Construction of Cold Spring Harbor began in 1917. Since the height of nearby Jayne's Hill was not available, Otto Kahn acquired a series of parcels north of Jericho Turnpike. The total land amassed was 443 acres at the cost of a staggering $1 million. On the estate acreage, Kahn and his construction team sought to create a new hilltop location from scratch, a massive undertaking requiring thousands of tons of soil. It took all of 1915 and 1916 for workers and horse-drawn wagons to haul the dirt necessary to achieve the elevation Kahn desired, with a view of Long Island Sound two miles away. Kahn selected the famed architectural firm Delano & Aldrich of New York City. (Both, courtesy of OHEKA Castle Hotel & Estate.)

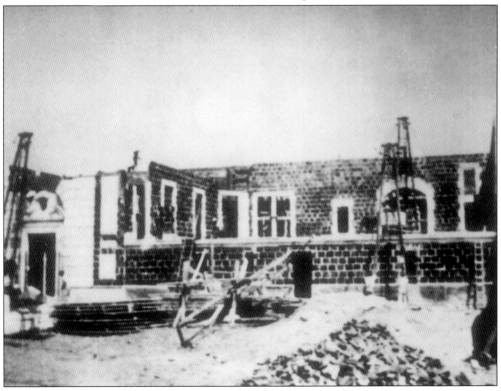

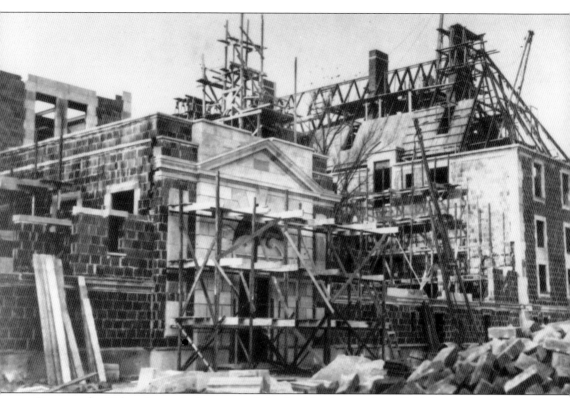

Because the Kahns lost priceless artwork in the Morristown fire, Cold Spring Harbor was substantially constructed with fireproof materials, including terra-cotta block, brick, limestone, concrete, and steel. Construction was underway at the onset of World War I. Otto Kahn's German-Jewish heritage generated rumors that he and his banking firm were pro-Germany. Kahn resented and publicly rejected these rumors. He had begun the American naturalization process years earlier in 1914, but the accusations served to push his hand. He had long believed that if he wanted to influence the American public and its economy, he should be an American citizen. For this reason, and to avert the scorn he and Addie had faced in Morristown, Kahn took the Oath of Allegiance on November 28, 1917. He became an American citizen just nine days before the United States entered World War I. (Courtesy of Huntington Historical Society.)

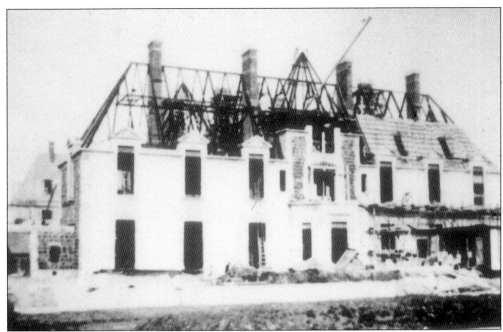

The Kahns were criticized for building a lavish palace during wartime. In response, Otto and Addie slowed down construction. They abandoned their plans to build an orangery and terraced gardens. For their hilltop mansion, the couple ordered the finest materials. The slate used for the chateau's sloping roof was installed by Rising & Nelson Slate of New York. Expert roofers deliberately simulated ripples and sags in the slate pattern to give the roof a wave-like pattern. Neighbors watched in amazement as turrets began to rise and horse-drawn wagons hauled dirt to elevate the site. The gardens and grounds were designed and built by Olmsted Brothers of Brookline, Massachusetts (sons of Frederick Law Olmsted, the "father of landscape design"). (Both, courtesy of Huntington Historical Society.)

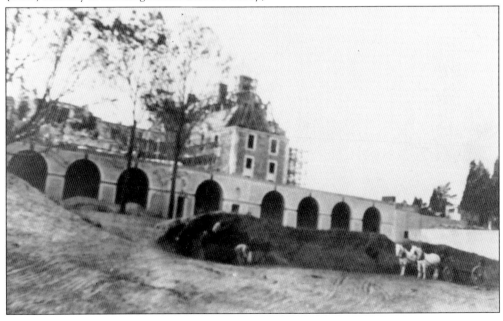

The Kahns' sons, Roger and Gilbert (right), and daughters, Margaret and Maud (below), moved into Cold Spring Harbor in 1919, where their parents hosted lavish galas. Guests included Helen Hayes, George Gershwin, Charlie Chaplin, Douglas Fairbanks, Sylvia Sidney, Ruth Gordon, Harpo Marx, Arturo Toscanini, Enrico Caruso, Dorothy Parker, the Ritz brothers, and Ziegfeld Folly girls. There were diversions to appeal to every possible interest: billiards, card games, ballroom dancing, tennis, swimming, golf, croquet, horseback riding, and nature walks, among others. Although Otto Kahn thrived in the company of many guests at such extravagant gala affairs, Addie was not known to particularly enjoy them. Instead, she would retreat to Europe or the solitude of their Fifth Avenue residence, leaving her husband to tend to what she referred to as his "zoo." (Both, courtesy of Anne Baugh Minnehan.)

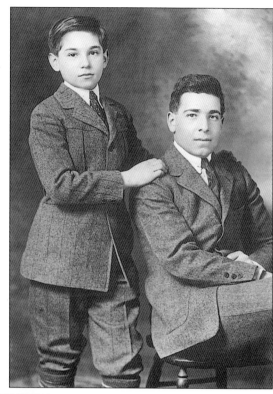

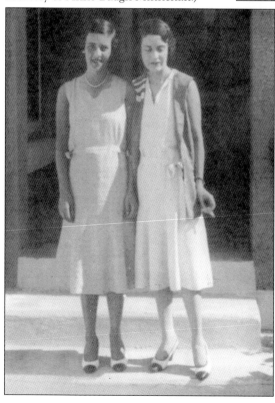

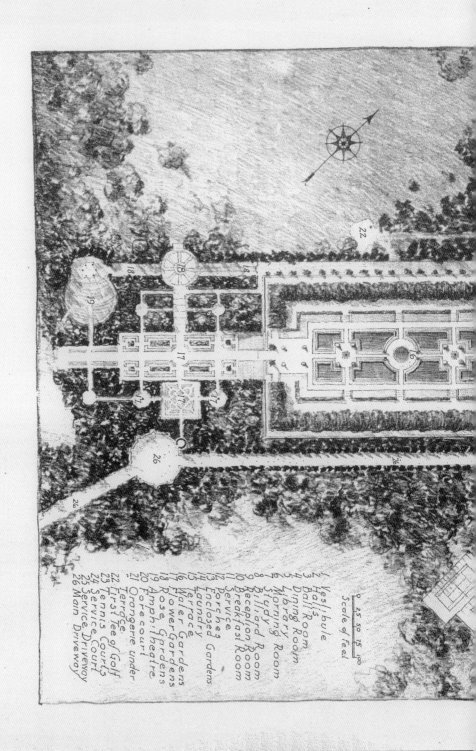

Scale of feet

0 25 50 75 100

1. Vestibule
2. Hall
3. Ball Room
4. Dining Room
5. Library
6. Morning Room
7. Study
8. Billiard Room
9. Reception Room
10. Breakfast Room
11. Service
12. Porches
13. Laundry
14. Enclosed Gardens
15. Terrace
16. Flower Gardens
17. Water Gardens
18. Rose Gardens
19. Amph-Theatre
20. Forecourt
21. Orangerie under Terrace
22. First Tee of Golf
23. Tennis Courts
24. Service Court
25. Service Driveway
26. Main Driveway

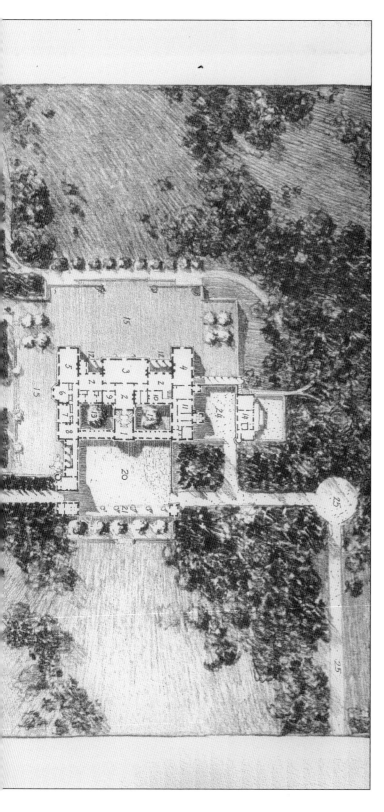

Possessing a keen sense of humor, Otto Kahn enjoyed poking fun at those who took themselves too seriously. The Ritz Brothers, a famous stage and screen and later television comedy team, were invited for an overnight stay at Cold Spring Harbor. Upon arrival, the youngest brother, Harry, exclaimed, "Let's louse the place up!" Al, Jimmy, and Harry Ritz came up with a plan. One evening, the brothers tiptoed down to the first floor with a bag of crockery secretly brought with them. They smashed every piece onto the mansion's floors. Both Kahn and the butler rushed to the scene. There, they discovered the Ritz Brothers once again up to their comedic tricks. Kahn described the prank as "the best thing" that had ever happened at Cold Spring Harbor. (Courtesy of OHEKA Castle Hotel & Estate.)

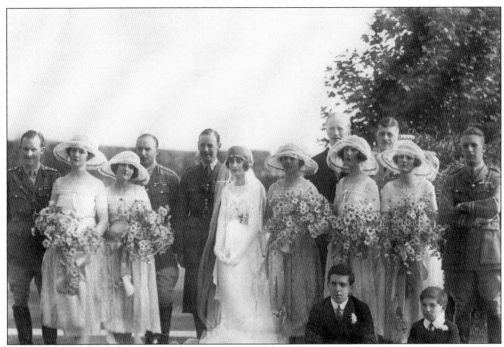

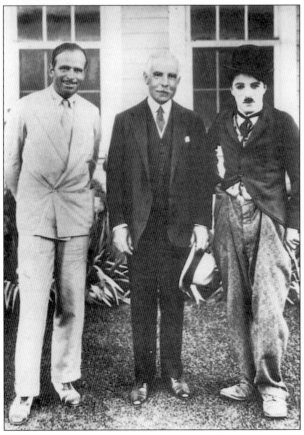

Maud and Roger Kahn celebrated their weddings at Cold Spring Harbor. Maud, the first bride at the mansion, is depicted at her wedding on June 15, 1920. A major social event, Maud's wedding to John Charles Oakes Marriot of Great Britain was captured on newsreel and shown at New York's Rialto Theatre. Roger's wedding to Hannah Williams, a Broadway performer, took place on February 8, 1931. The Kahns' guests entered the mansion through its dramatic entrance hall, which revealed one of the famous and breathtaking features of the house, the grand staircase. The staircase was patterned after the exterior stairway of the Chateau Fontainebleau in France and led to the reception hall. Among OHEKA's many guests were Charlie Chaplin and Douglas Fairbanks, seen standing on either side of Kahn in this photograph. (Above, courtesy of Anne Baugh Minnehan; left, courtesy of OHEKA Castle Hotel & Estate.)

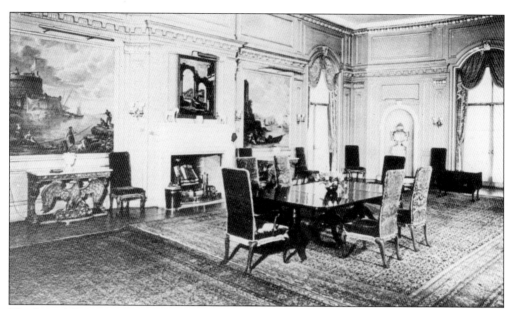

The formal dining room and library appear in these photographs. The dining room was designed to be grand and elegant, yet gentle and refined, reflecting Addie's tastes. It easily accommodated dinner parties of 50 or more guests. At such parties, personal valets would be assigned to each guest at the table. Kahn's stately library was designed to replicate the wood-paneled library at his New York City mansion. The walls were hand-painted with a mixture of plaster and brown paint. Graining combs and rollers were used to give the surface the texture, luster, and warmth of wood paneling without the use of wood. The process fulfilled his fireproof requirement to an even higher standard than that of his Manhattan residence, which was simultaneously being constructed. (Both, courtesy of Huntington Historical Society.)

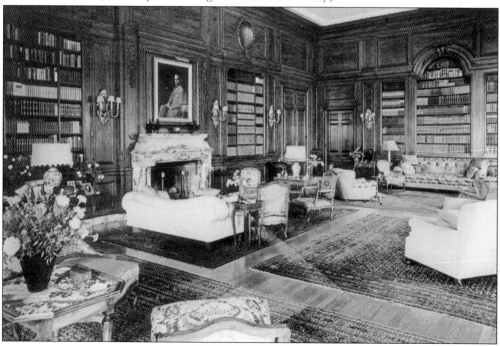

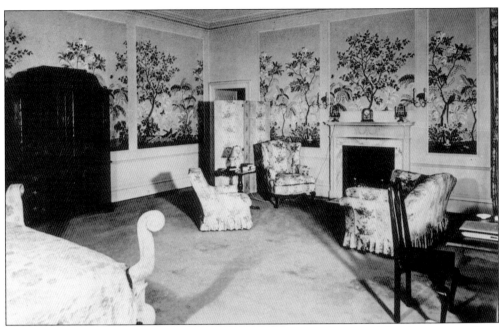

Otto and Addie enjoyed side-by-side master bedroom suites in the second floor's west wing. Each was decorated with wallpaper and hand-painted, silk murals. Addie's bedroom is shown above. The suites included a dressing room and a bathroom with gold-plated fixtures. The couple shared a sitting room with an outdoor terrace that overlooked their impeccable formal gardens. In all, there were 13 bedroom suites, 12 baths, 3 spacious sitting rooms, and a linen room on the second floor. A generator ensured the estate's self-sufficiency in the event of power failure. In addition, the basement included specially designed tunnels to promote air circulation. The sophisticated system of wind tunnels and air ducts captured breezes from Long Island Sound and moved air throughout the mansion. This innovative cooling system predated the age of modern air-conditioning. (Both, courtesy of Huntington Historical Society.)

Depicted here are raised brick terraces and walking paths located in the formal gardens. The Kahn estate grounds also included every amenity imaginable. The 443-acre property featured an 18-hole golf course, clubhouse, horse stables, greenhouses, three gatehouses, formal gardens, reflecting pools, fountains, statuary, gazebos, an amphitheater, rose gardens, miles of bridle paths, walking paths, a 10-car garage, working farm and dairy, indoor lap pool, tennis courts, airstrip, and racetrack. In 1922, the *New York Times* described the Kahns' Long Island home as "the finest country house in America." Aerial views of the mansion and its gardens were portrayed in the opening scenes of the 1941 Orson Welles film classic *Citizen Kane* to depict Charles Foster Kane's fictitious mountaintop castle known as "Xanadu." (Both, courtesy of Long Island Studies Institute.)

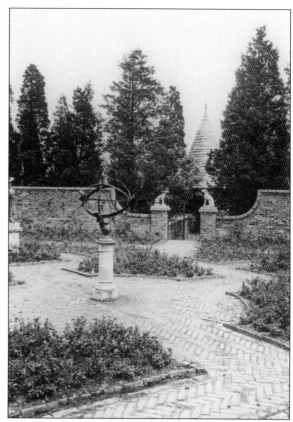

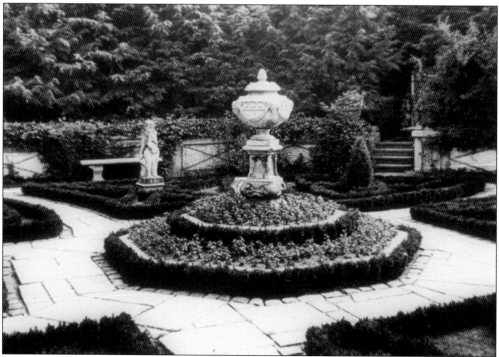

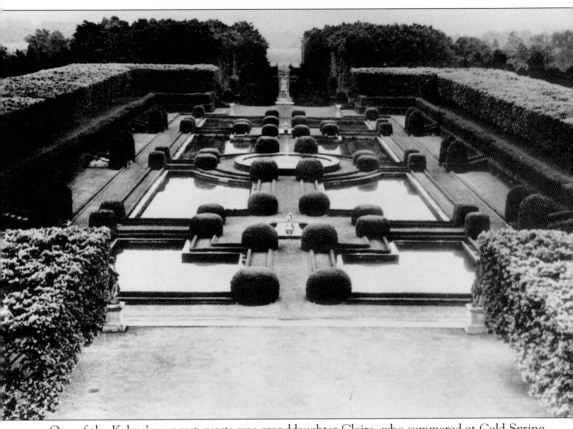

One of the Kahns' youngest guests was granddaughter Claire, who summered at Cold Spring Harbor during the early 1930s. Claire befriended Rosemary Dunning, the daughter of Kahn's head butler, Robert K. Dunning. Unlike other children who lived on the estate, Rosemary enjoyed the privilege of being permitted inside the mansion, where she followed her father as he performed his daily duties. "Claire and I often enjoyed an advance taste of the treats being prepared in the kitchen that would later make their grand debut on Easter Sunday," Rosemary recalled. "We felt so important." She also remembered when, as a young child, she found herself hopelessly lost on the estate's golf course. Otto and his golf partner, Edward, Prince of Wales, rescued the girl. When the child's mother opened the door, she was stunned to find Otto and the prince with outstretched arms presenting her missing daughter. "I can still remember the look of shock on my mother's face when she opened the door and saw Mr. Kahn and the Prince of Wales," Rosemary recalled years later. (Courtesy of Huntington Historical Society.)

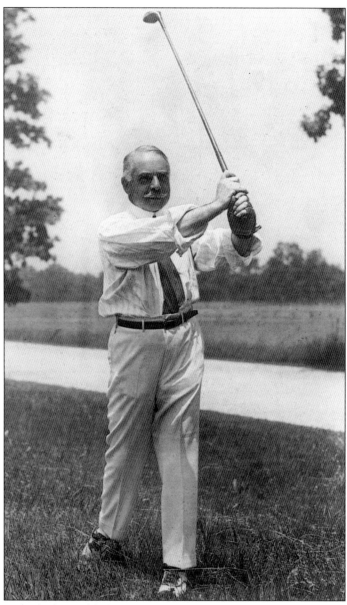

The mansion overlooked a world-class, 18-hole golf course. Golf was a pastime that Otto Kahn enjoyed but never mastered to his satisfaction. Having a sense of humor, he had sand traps constructed where his guests had landed their drives. It has been said that he placed more than 100 traps to unnerve his golf partners. In 1926, plans for the Northern State Parkway called for a route through the golf course. When informed of this threat to his acreage, he presented $10,000 for new surveys placing the parkway south of his estate. The money was accepted by then state parks commissioner Robert Moses, who later denied the encounter. Years later, author Robert Caro questioned Moses about the Kahn resurvey during an interview for his biography about Moses entitled *The Power Broker: Robert Moses and the Fall of New York*. Moses refused to continue the interview and never spoke to Caro again. In the end, the mansion and golf course, with a construction cost of $9 million, was easily the Kahns' greatest building achievement. (Courtesy of Anne Baugh Minnehan.)

Among Otto Kahn's legacies is his contribution to American opera. In 1903, he bought stock in New York City's Metropolitan Opera to save it from collapse. Nonetheless, he suffered under a policy that no Jew be permitted to own an opera box. Kahn was not permitted to purchase one until 17 years later, after his election to the board. But he rarely used his box. Instead, Kahn insisted it be occupied by music students from Huntington High School. Marion Weithorn was one of those students. "It was an unforgettable experience," Weithorn reminisced. "I had nothing suitable to wear. Every piece of my attire was on borrow, including my white gloves," she said. In addition to supporting the Met, Kahn brought Arturo Toscanini from Milan's La Scala to conduct its orchestra. He also acquired lead opera singer Enrico Caruso, who is pictured here with Kahn. Kahn was the chairman of the Met from 1911 until 1918 and president until 1931. (Courtesy of OHEKA Castle Hotel & Estate.)

Otto Kahn's friendships were not limited to Wall Street power brokers, industrialists, high society, and European aristocracy. He befriended then unknown artists, including poet Hart Crane, George Gershwin, and Arturo Toscanini, to whom he provided financing. He also financed struggling entertainers. In 1923, Paul Robeson wrote to Kahn, "I am Paul L. Robeson, Rutgers 1919, Columbia Law School 1922, Negro, Phi Beta Kappa, and Walter Camps All-American End 1918." In response, Kahn provided financing for Robeson's voice lessons. Later, his operatic and film career became legendary. Kahn's philanthropy and his life ended on March 29, 1934, when he suffered a fatal heart attack. His body was taken to his New York City mansion, where it laid in state. Addie was too heartbroken to make arrangements for several days. Funeral services were held in the ballroom at Cold Spring Harbor. Rabbi Samuel H. Goldenson of Temple Emanu-El performed the service, as Kahn wished to remain faithful to his Jewish heritage to the end. Those in attendance included J.P. Morgan, Felix Warburg, and Theodore Roosevelt Jr. (Courtesy of Huntington Historical Society.)

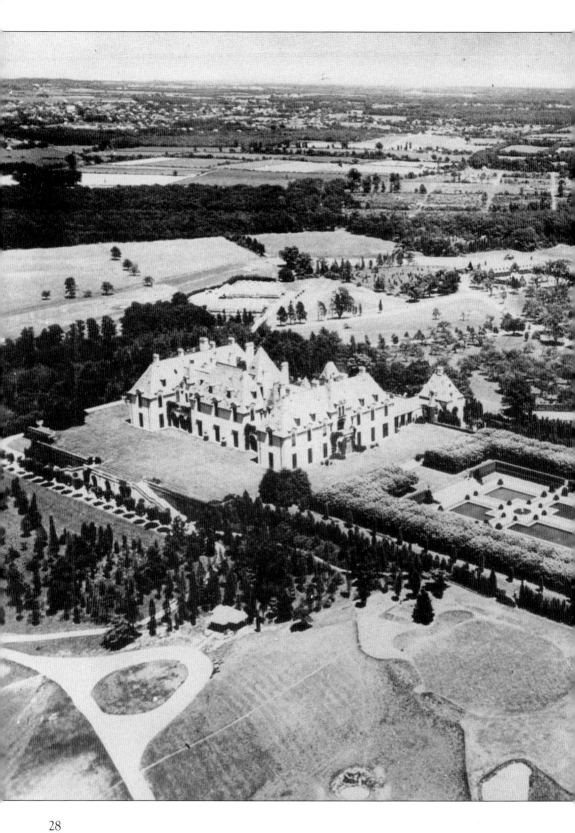

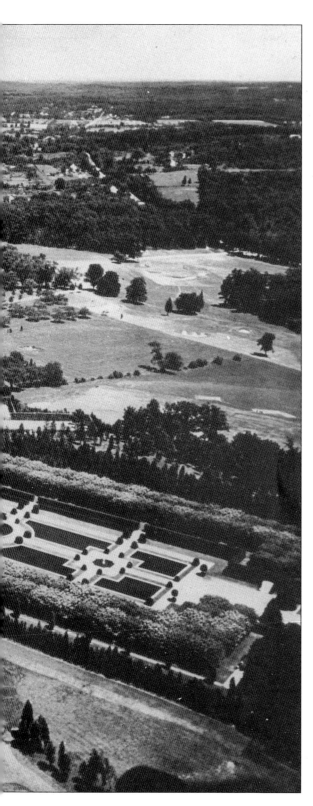

Otto Kahn was interred in the Olmsted-designed family plot at St. John's Cemetery in Laurel Hollow in New York. His close friend Bernard Baruch said, "He would rather have lost a million dollars than a friend." Kahn gave generously to countless struggling cultural and educational institutions and individuals throughout America. His aim was to ensure that the arts would be accessible to every American, regardless of social or economic status. He believed that it was society's mandate to foster a love for the arts in young people. Addie Kahn died in London in 1949 after suffering a heart attack. Arranged by her son Gilbert, an Episcopalian minister, an Episcopalian ceremony took place at St. John's Cemetery. She was buried beside her husband. (Courtesy of Huntington Historical Society.)

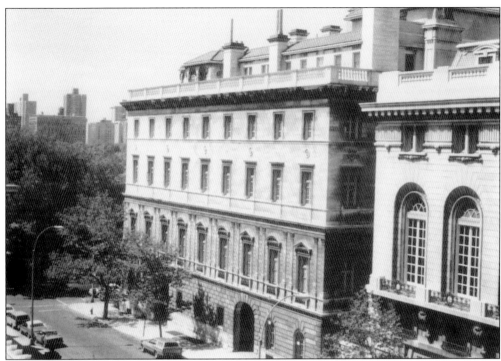

After her husband's death, Addie sold the couple's real estate holdings to avoid property taxes. Their primary residence at 1100 Fifth Avenue in New York City, shown here, was sold in 1934 to Convent of the Sacred Heart. By that time, Cold Spring Harbor was rarely used. It was not the only Gold Coast mansion going through a transition. By the 1930s, dozens of estate mansions along Long Island's scenic North Shore were beginning to disappear. Just like Cold Spring Harbor, the owners of those properties, too, found themselves struggling to pay huge bills for their upkeep. In other cases, one by one, vacated manses were lost to fire—permanently altering Long Island's Gold Coast. (Above, courtesy of OHEKA Castle Hotel & Estate; below, courtesy of Long Island Studies Institute.)

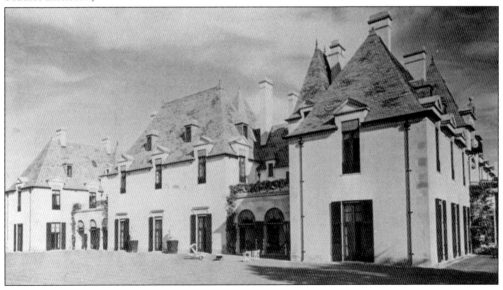

Two

SANITATION RETREAT
1939–1940

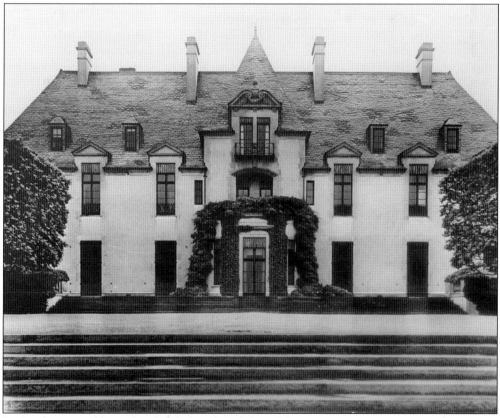

In April 1939, Addie Kahn decided to demolish Cold Spring Harbor to avoid the $25,000 in property taxes. Two months later, the estate was sold to the Welfare Fund of the New York City Department of Sanitation as a "recreational and rest center" for the members of the department and their families. Cold Spring Harbor was renamed "Sanita." (Courtesy of Madeline Fox.)

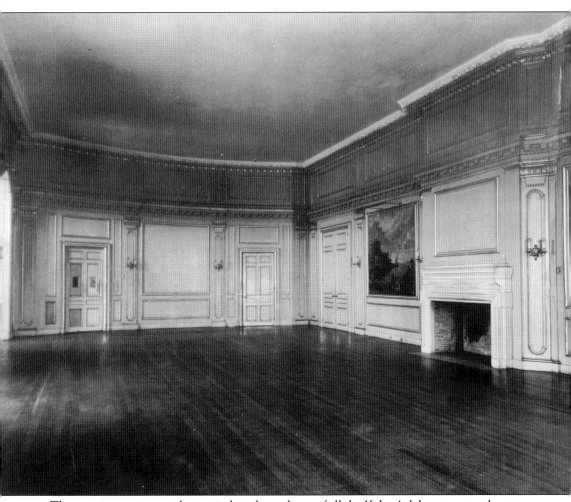

The mansion was promptly emptied, as shown here, of all the Kahns' elaborate artwork, statuary, furnishings, and tapestries with the exception of a seven-foot stuffed tarpon (later reported missing and never found). Rare volumes from Kahn's book collection were removed. The house was redecorated by Mrs. Carey, wife of Commissioner William Carey, and the couple took over the Kahn suites, which overlooked the reflecting pools. The grand space was set aside for Commissioner Carey and his family when they visited Sanita. If the decision to immediately open Sanita was the "shot across the bow," invaders from New York City "dropped the bomb" on July 9, 1939. It was on that day that Cold Spring Harbor neighbors and the rest of Long Island watched with horror and amazement as an estimated 20,000 New York City sanitation workers and their families first visited Sanita. The city's plan was to open Sanita first and then argue about the taxes and zoning issues later. (Courtesy of Madeline Fox.)

They arrived in 3,000 automobiles, 82 buses, and 2 Long Island Railroad trains, running directly to the Cold Spring Harbor Railroad Station. The event was blessed by priests and cursed by politicians. Neighbors were aghast at the spectacle. Every amenity expected of a New York City sanitation retreat awaited the 20,000 visitors. A beer license was prominently displayed on the wall of the reception hall. Caterers Horn and Hardart Company of New York City serviced the ballroom, which was converted for cafeteria-style dining. Card tables were set up in some of the bedroom suites with games of gin rummy taking place. Horn and Hardart had also set up tables in the formal gardens and was selling cheese, salami, bologna, ham, and liverwurst sandwiches. A cigar stand was also set up. (Both, courtesy of Madeline Fox.)

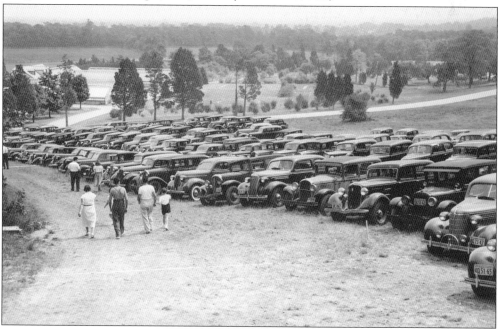

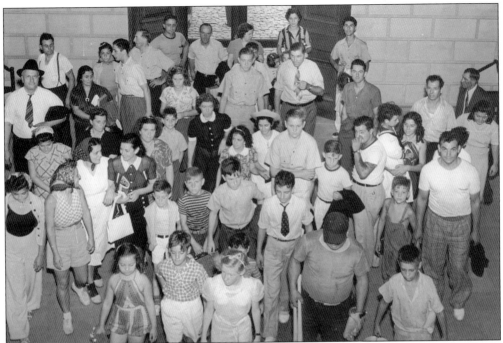

By the end of the afternoon, 35 kegs and 18,000 bottles of beer had been consumed. Well over 6,000 frankfurters, 40,000 gallons of soup, a ton of roasted meats, and countless hamburgers were sold. By building up the walls with cinder blocks, two of the reflecting pools in the formal gardens were converted into swimming pools at a depth of 5.5 feet. Throughout the mansion, throngs of visitors walked and talked. One guest exclaimed, "This is like the world's fair!" (The world's fair was taking place in New York City at that time.) Shown in the photograph above, guests arrive at Sanita. In the photograph below, guests set up picnic tables. (Both, courtesy of Madeline Fox.)

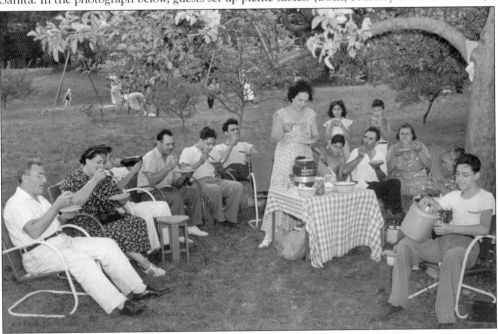

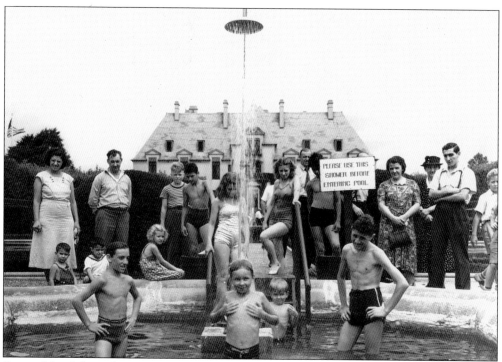

Some of the clubs in the sanitation department had already arranged for summer rentals for 200 of their members. Aside from renting all the estate buildings (gardeners' cottages, caretakers' homes, farm, and garage buildings), 15 single bedrooms, 20 small double rooms, and 8 large rooms inside the mansion were rented as dormitories. The charge for the dormitories was $1 per night. The double rooms in the mansion were $1.50, with single accommodations sold at a slightly higher price. Sanita's outdoor amenities were put to new recreational uses. These photographs show the reflecting pools when they became swimming pools. (Both, courtesy of Madeline Fox.)

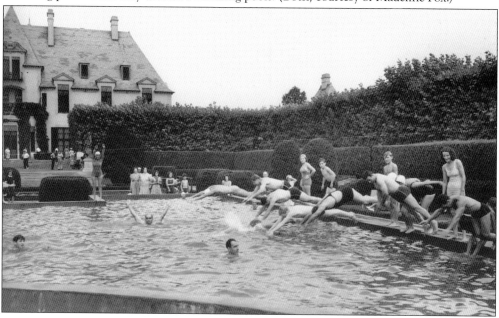

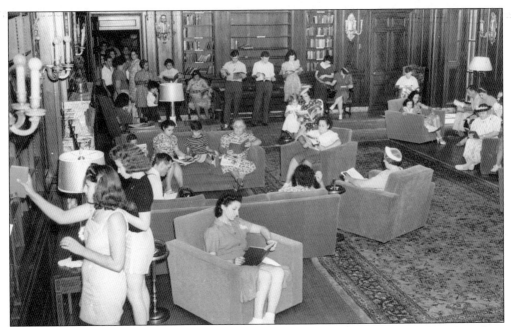

Visitors enjoyed reading in the library, above, and eating in the dining room, below. Outside, a dedication ceremony was held on a terrace overlooking the formal gardens. From the second-floor balcony, Commissioner Carey announced that a huge outdoor swimming pool was under construction. The pool, however, was never built. Carey also stated that as many as 300 cottages would be built for summer rentals. By this point, some of the men had already reduced their attire to T-shirts and suspenders. The Kahns' sons, Gilbert and Roger, were present. "I still cannot believe what I am seeing here today," Roger commented. Addie Kahn, who had conveniently sailed for Europe the previous week, did not attend the opening. (Both, courtesy of Madeline Fox.)

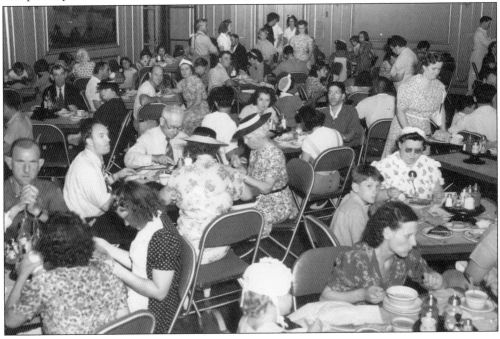

But the enjoyment of Sanita was short-lived. On August 3, 1939, a New York Supreme Court judge granted the Town of Huntington a temporary injunction that prevented Sanita from operating. The judge ruled that the city's sanitation department violated Huntington's zoning code by operating a "lodge" in a residential neighborhood. Admonishing the attorney representing the sanitation department, the judge said, "You couldn't do in New York City what you have attempted to do in Huntington." Backed by thousands of local residents, the Town of Huntington wasted no time pursuing a more permanent resolution from the state court system. By January 1940, a permanent injunction was issued barring Sanita from operating. The town had successfully prevented the city from doing an end-run around its local ordinances. (Both, courtesy of Madeline Fox.)

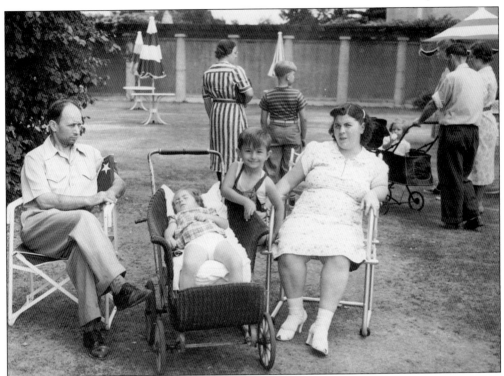

In New York City, word spread quickly of the court's ruling. City officials notified Mayor Fiorello La Guardia of the situation. After giving the matter some thought, the mayor decided to give Sanita one last chance. He would appeal directly to town officials and offer to pay one-third of the tax bill. So now, the hardworking and proud New York City sanitation workers had summoned their greatest political warrior to do battle with Long Island politicians. By that time, the conflict had taken on a new social class dimension, as La Guardia found himself defending the honor of his blue-collar workers. Local politicians were not too shy to proclaim that they simply did not want the likes of "those people" coming to their town. (Both, courtesy of Madeline Fox.)

If Mayor La Guardia was unable to strike a compromise that would allow the New York City Welfare Fund to use the property as a tax-exempt recreational center, then the mansion would be demolished. The matter between the City of New York and the Town of Huntington languished in the court system for nearly a year. On March 6, 1940, La Guardia traveled to Huntington to face-off with town officials. It was ironic that the mayor was advocating for the use of his friend's former mansion. Shown here, sanitation workers bask in the sun and play bocce in the summer of 1939. (Both, courtesy of Madeline Fox.)

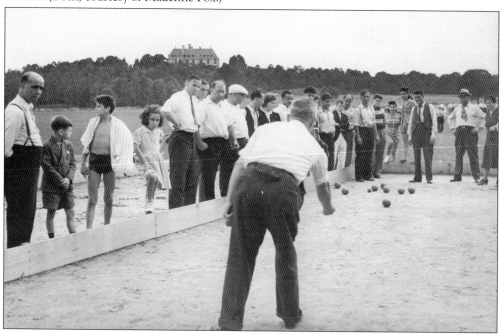

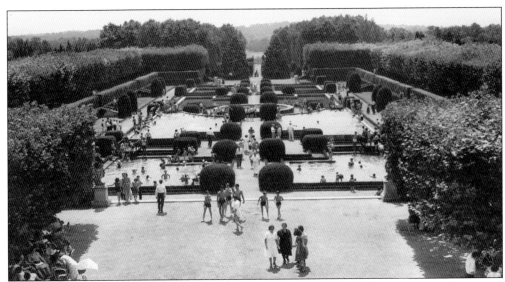

Although La Guardia dashed for the showdown with town officials, the prospects of winning were slim. The answer was quick and firm: there would be no deal. La Guardia said upon leaving the meeting, "I wouldn't want to be as dead as this proposition is." In March 1940, a mere eight months after its grand summer opening when visitors strolled the gardens and posed with the band, shown above and below, Sanita was permanently closed. But in dozens of offices and on hundreds of garbage trucks in New York City, that one glorious summer day would remain in the memories of thousands of sanitation workers who briefly found their very own "heaven on earth" in Cold Spring Harbor, Long Island. It was their Xanadu; they called it Sanita. (Both, courtesy of Madeline Fox.)

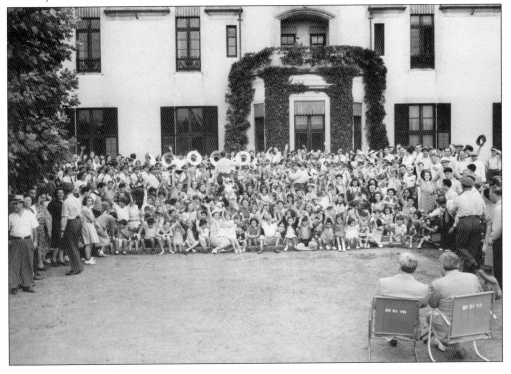

Three

RADIO DAYS

1943–1945

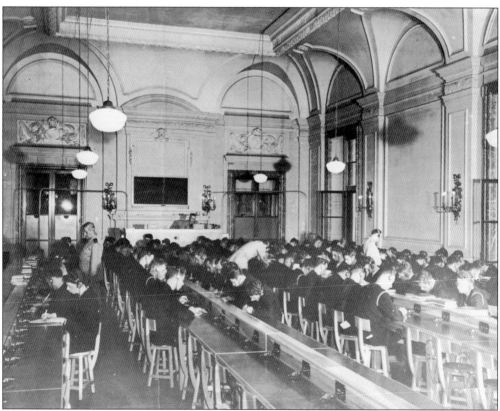

On March 28, 1943, Merchant Marine Samuel Pearsall stood at the threshold of the most extravagant bathroom he had ever seen. Private Pearsall of the US Maritime Service was just deployed to the Kahn Station, the Kahns' former mansion. He did not know it yet, but he was in Addie Kahn's custom-built bathroom. Cadets learn code in the ballroom. (Courtesy of Madeline Fox.)

Over the next eight weeks, Private Pearsall worked hard to become a proficient maritime radio operator. Three years earlier, on April 19, 1940, New York City transferred ownership of the 443-acre Kahn estate to Realty Associates of Brooklyn. Soon afterwards, they announced plans to construct Cold Spring Hills, a residential center of small estates with homes of authentic colonial architecture. There was no plan, however, for the mansion. Then came December 7, 1941, the day of infamy that brought death and havoc to Pearl Harbor. As the world's eyes watched its aftermath, little attention was paid to happenings on Long Island. Men and women were going to war. All of America had its eyes turned west, to the Pacific. The library is shown above, and cadets gather in the dining room below. (Both, courtesy of Madeline Fox.)

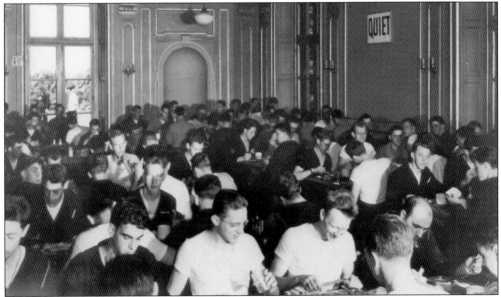

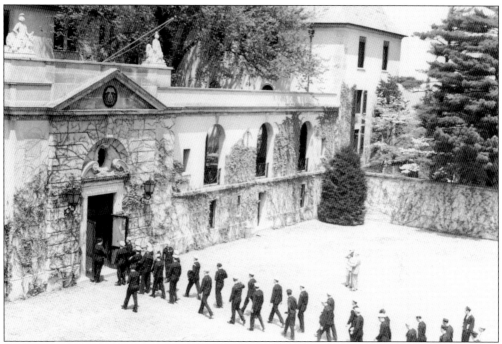

In March 1943, Realty Associates announced it had leased the Kahn mansion to the United States War Shipping Administration as a school for maritime radio operators. The training center would house 480 Merchant Marine radio operator trainees and an administrative staff of 160. Seamen trained at the Kahn Station would help win the war in Europe by operating the radios that guided supply ships to US troops stationed overseas. It was critical for them to learn their jobs; some of them would be the lifeline between their ships and others in the convoys that sailed the Atlantic. Men came from throughout the nation to be trained in Huntington, Long Island. Above, cadets enter Kahn Station. Below, third from the left in back row, Private Pearsall stands under a window. (Both, courtesy of Samuel Pearsall.)

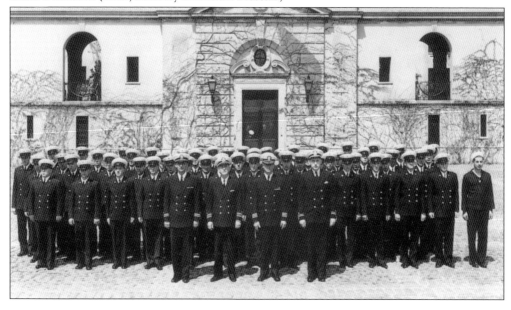

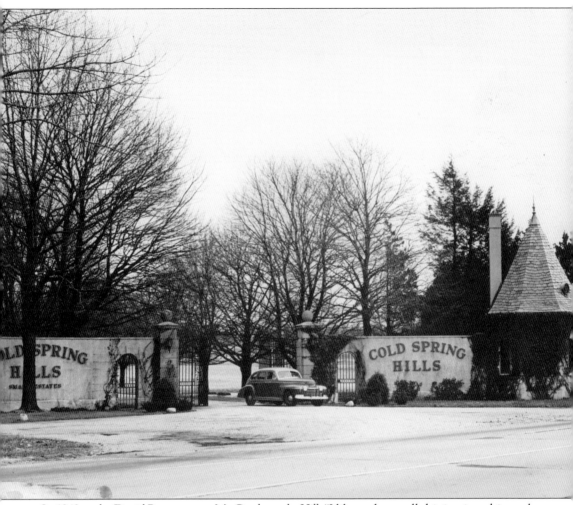

In 1943, cadet David Rynne wrote *My Castle on the Hill:* "I like to dream all this is mine, this castle on the hill. / And though I know it isn't so, it gives me quite a thrill. / I walk along its winding road, I gaze upon its view. / I make believe this is my home, for in a way it's true. / I wander through the old courtyard, and through the gardens too. / I see it bathed in bright sunlight, and dressed in starry blue. / I still recall when first I saw, my castle on the hill. / It seemed so sad and lonely then, so dreary, dark and still. / But now it smiles and seems alive, so glad to lend a hand. / To shelter men who go to sea to save our gallant land. / Perhaps you think I'm just a fool to dream the way I do. / But I have grown to love this place, and I know you will too." By 1945, with the war's end, the mansion had once again lost its purpose. (Courtesy of Madeline Fox.)

Four

MILITARY SCHOOL
1948–1979

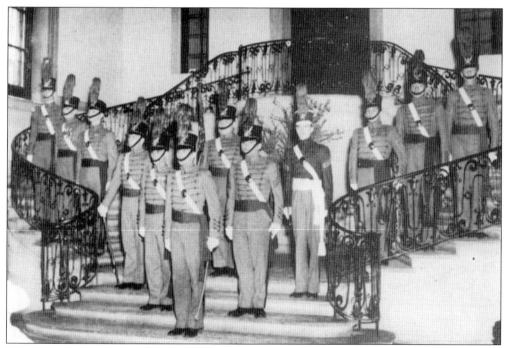

In July 1948, the mansion became a boys' preparatory school called Eastern Military Academy (EMA). EMA began on September 27, 1948, with 98 cadets. Nevertheless, its enrollment would grow, as would its reputation. Known as an outstanding college preparatory school, the school's motto was "What you are to be, you are now becoming." Its slogan, "A Superior Military Academy," would define the school for decades. (Courtesy of James J. Darmos.)

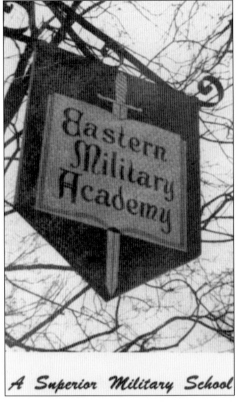

A Superior Military School

In September 1952, ten-year-old Roger Hall entered the fifth grade. At the time, military boarding school was a common option for families looking to instill discipline and structure into their sons' lives. The ballroom, now EMA's gymnasium, had scoreboards hanging from the ceiling and quilted floor mats stuffed into the two fireplaces at either end of the room. There were varsity sports programs to choose from, including football, tennis, baseball, lacrosse, and music. In 1954, Roger joined the Lower School Glee Club while in the sixth grade. That same year, 17-year-old Frank Scalia was accepted into EMA as a junior upperclassman. Frank was amazed when he first saw the school. His dormitory room overlooked the surrounding golf course, and he could see Cold Spring Harbor in the distance. (Both, courtesy of James J. Darmos.)

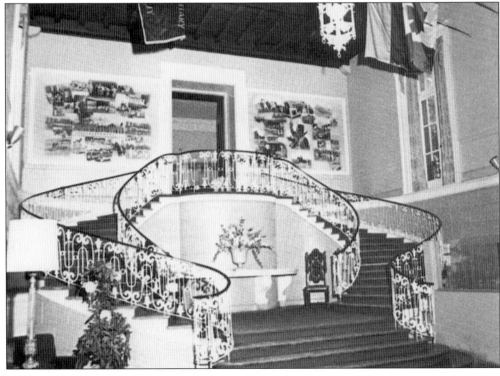

The beautiful surroundings of EMA gave the school a country club atmosphere. Cadet Frank Scalia soon settled in and later reflected that the school fit him "like a glove." He recalled that the staff was excellent, especially the school's founder, Roland R. Robinson. EMA's goal was devoted to developing a young man's strength in character and leadership skills by enforcing systematic habits of study and correct personal and social behavior. Like many other boys, Frank liked attending military school at a time in America when such institutions were popular. These were times of respect, patriotism, family values, stability, progress, and development. Pictured here are EMA cadets at work and at play. (Both, courtesy of James J. Darmos.)

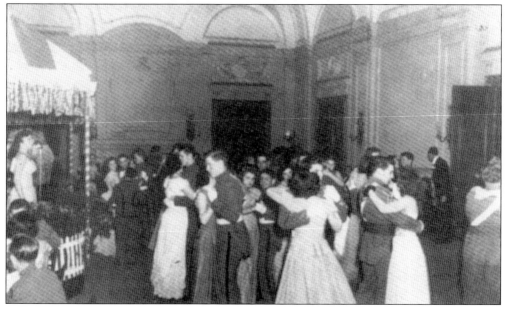

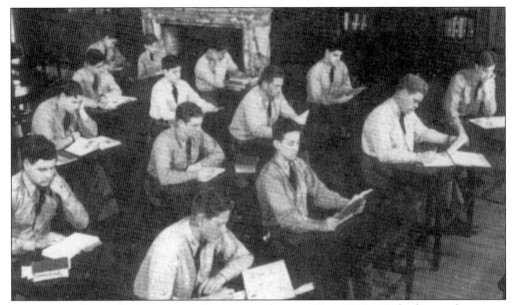

Frank Scalia felt mixed emotions about his graduation from EMA. He had gained a strong education, participated in many sports, and achieved friendships that would last for many years. On graduation day, cadets honored their school by marching along the paths surrounding the Kahns' gardens, now known as the "senior walk." In its heyday in the late 1950s, EMA enrollment peaked at 600 cadets, with approximately one-third of them boarding. Cadets are shown here in the school's study hall and dining hall. (Both, courtesy of James J. Darmos.)

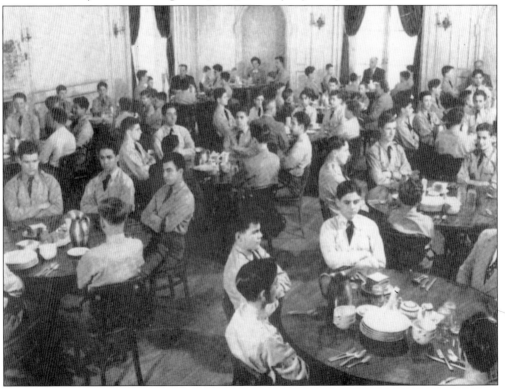

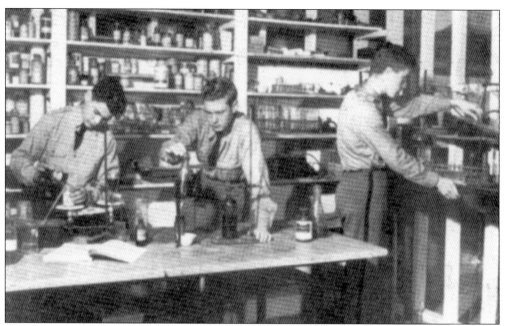

By the mid-1960s, the era of heightened patriotism, family values, progress, and stability had ended in America. The human tolls of the Korean and Vietnam Wars were felt at EMA, where war casualties included cadets Paul Charles Rudy (class of 1959), Channing Allen Jr. (class of 1961), Dennis B. Murry (class of 1965), Louis Paralez Jr. (class of 1966), and Joseph DeGennaro (class of 1969). During the late 1960s and early 1970s, enrollment declined with the unpopularity of the war in Vietnam. Many parents were no longer enthusiastic about sending their sons to military school. Plummeting enrollment and increasing maintenance costs took a toll. By 1978, the school was approaching bankruptcy. The science lab and swimming pool are pictured here. (Both, courtesy of James J. Darmos.)

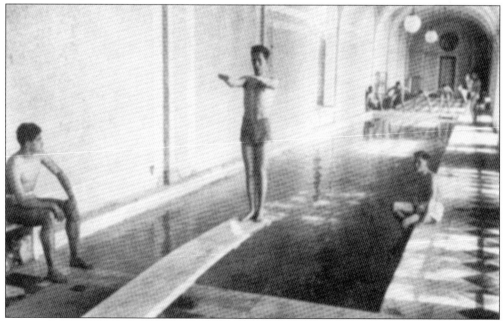

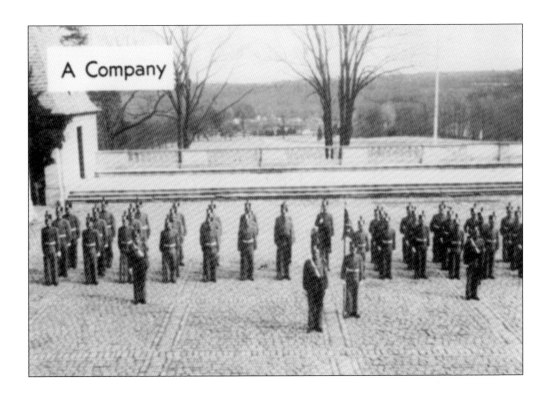

Some of the finest youth in America came through the prestigious Eastern Military Academy, which once claimed the Kahn mansion as its campus. In the spring of 1979, the final graduates received their diplomas. Cadets stand in courtyard formation above and at their graduation ceremony below. (Above, courtesy of James J. Darmos; below, courtesy of Leo Hedbavny Jr.)

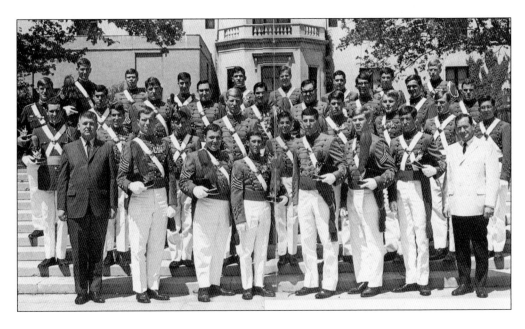

Five

ABANDONMENT AND DEVASTATION 1979–1983

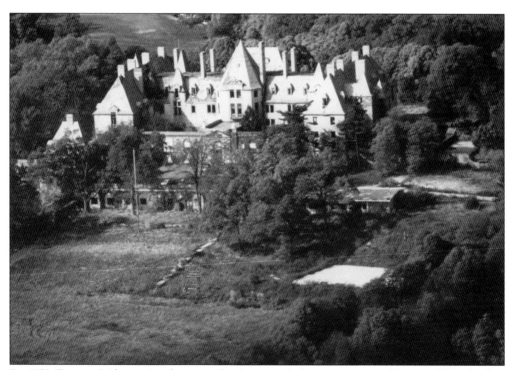

By 1979, Eastern Military Academy was bankrupt and the mansion stood empty. After the last cadet had left, teenagers flocked to the building at all hours of the day and night. Word spread quickly that the academy was vacant. What followed over the next year was the systematic destruction of the building at the hands of vandals and arsonists. An aerial view of the empty mansion is pictured here in 1979. (Courtesy of OHEKA Castle Hotel & Estate.)

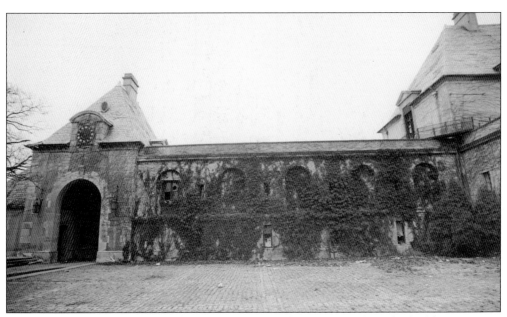

First the professional vandals arrived, removing everything of value from the building's interior and exterior, including mantels, fixtures, railings, pedestals, and statuary. Next came the amateurs, who simply burned the contents of every room in the building. Others came to explore or "party," until they were chased away. The building had become a huge cause of concern for neighboring residents. In August 1979, resident and Cold Spring Hills Civic Association president Ellen Schaffer explored the abandoned mansion and saw firsthand the massive destruction caused by vandals and troublemakers. Association members asked Schaffer to evaluate the mansion's current condition and report to them on what could be done to improve the situation. The courtyard and formal gardens are shown here in 1979 after years of neglect. Note EMA's Quonset huts below. (Both, courtesy of Shari Nocks Gladstone.)

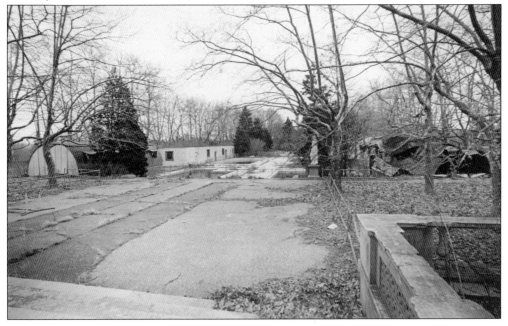

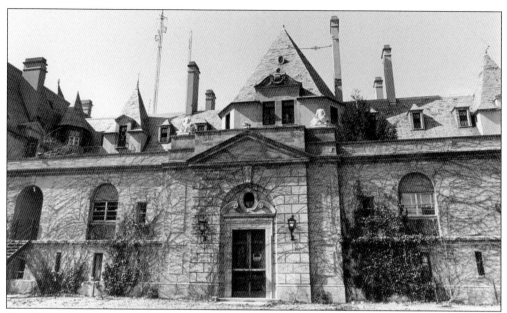

The front entrance of the mansion was in shambles. Vines covered the facade. Every window was shattered. Littered with trash, the entryway was painted military blue. The mansion towered above the tallest of the nearby trees. A small balcony on the third floor offered breathtaking views of Cold Spring Harbor and Long Island Sound. It was possible to see the greens and fairways of the Cold Spring Country Club golf course and traffic along Jericho Turnpike more than a mile to the south. Another window afforded a view of Oakwood Road more than two miles to the east. Walt Whitman High School and Stimson Junior High School were visible in the distance. What was left of the great lawn was covered with tall brown grass. The dull, wispy, brown turf stretched to the south like a huge piece of burlap. The front entrance and grand staircase are pictured here in 1979. (Both, courtesy of Shari Nocks Gladstone.)

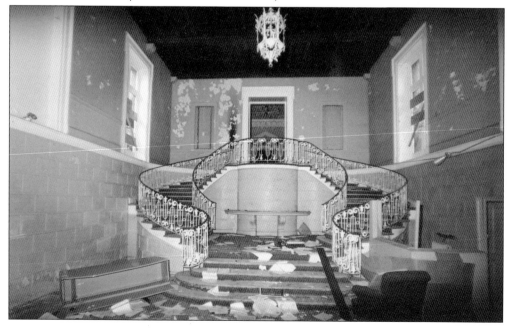

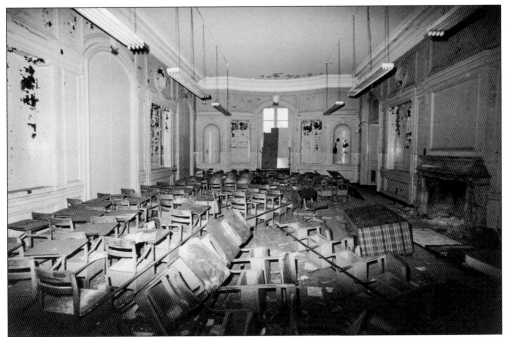

The destruction extended into every room. Most of the hand-carved marble and stone fireplace mantles had been carted away. Apparently, vandals had used dollies to haul their loot out of the building. Marks left by the dollies' wheels were evident in rooms and hallways, on stairs and doorways. With no electricity and nothing working inside the mansion, the only sounds came from the footsteps of the association members and the birds that had flown in through the broken doors and windows. The library, above, and dining room, below, are pictured here in 1979. (Above, courtesy of Shari Nocks Gladstone; below, courtesy of OHEKA Castle Hotel & Estate.)

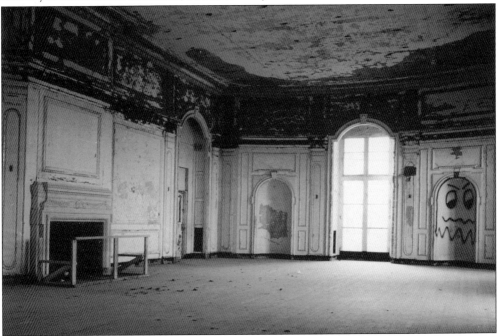

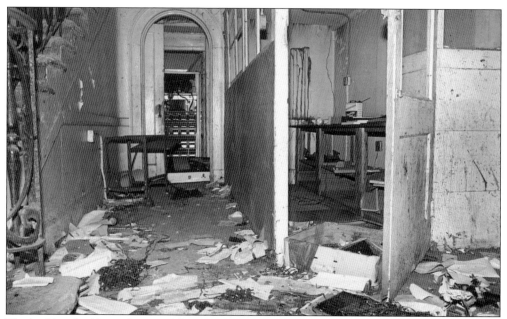

The building had been destroyed down to its very core. Despite its deplorable condition, however, it retained a certain beauty and elegance because of its rising walls and turrets. Longtime residents argued that "the castle" helped give the neighborhood unique character. Children were awestruck just to be near it. Young and old, everyone loved the place, and everyone wanted to join in the effort to save it. From 1980 to 1981, the association searched for adaptive reuses that could work for the building. Members wrote letters to politicians, contacted local newspapers, and tried everything possible to effect change. Vandalism on the main floor and in a bathroom is shown here. (Both, courtesy of Shari Nocks Gladstone.)

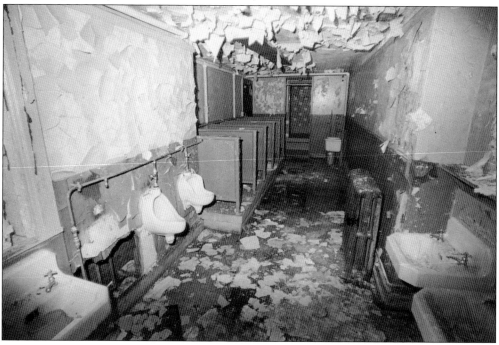

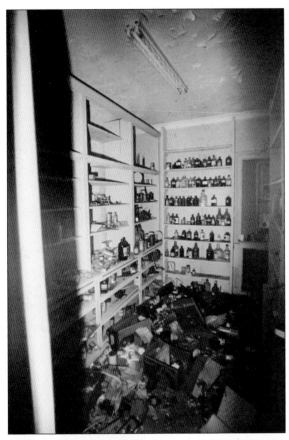

The association knew the mansion could no longer be used as a single-family residence. It advocated for its conversion to condominiums, which was a preservation tool used elsewhere in the United States and on Long Island. Meanwhile, vandalism and arson persisted every weekend, reaching an all-time high in the summer of 1982. The accumulation of 30 years of school furniture and equipment (left behind by Eastern Military Academy) was piled into heaps and set ablaze, but the fireproof structure of concrete, brick, and steel would not burn. Then, in September 1983, developer Gary Melius contacted the association to discuss the future of this "diamond in the rough." These 1979 photographs shows Eastern's science lab and outdoor devastation. (Both, courtesy of Shari Nocks Gladstone.)

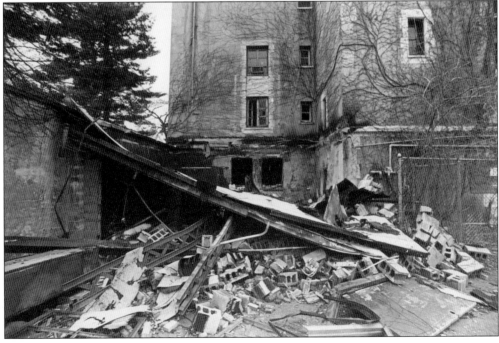

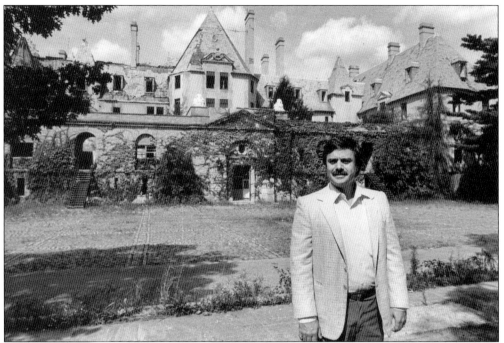

Gary Melius described how he wanted to restore the structure to its former glory. He was aware of the rezoning of the land to permit 50 condominiums and that the action had the support of neighbors. Melius's plans called for the refurbishment of the main rooms on the first floor for use as common areas. The formal gardens, which no longer resembled "gardens," would be rebuilt to reflect the grandeur of the original mansion. The plan was both bold and expensive. But Melius remained convinced it was possible to save this important piece of Long Island's Gold Coast. Pictured above, Gary Melius stands in front of the mansion in 1984. Below is the mansion's west side with an addition built by EMA. (Above, courtesy of OHEKA Castle Hotel & Estate; below, courtesy of Shari Nocks Gladstone.)

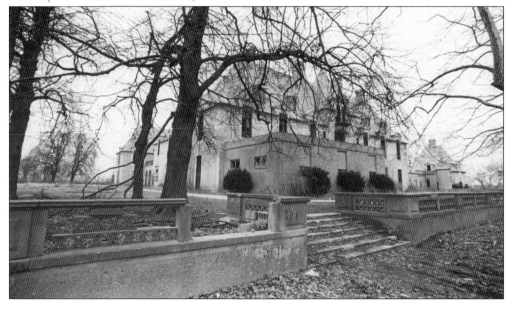

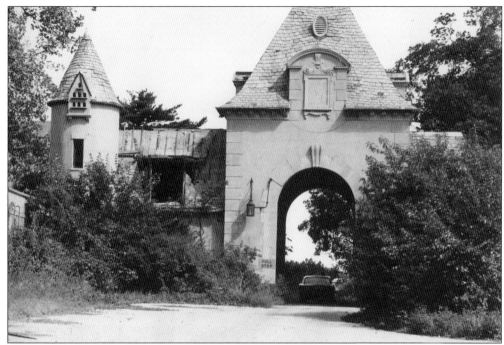

Ellen Schaffer informed Gary Melius that the mansion was known as OHEKA, the summer home and weekend retreat of Otto Hermann Kahn. Melius liked the name and wanted to include it in his plans. Though Melius was an accomplished developer and respected businessman with a team of real estate development and sales professionals, nothing could have prepared him for the challenge he was about to confront at OHEKA. Pictured above in 1984 is OHEKA's overgrown gatehouse. Below is an aerial view of OHEKA in ruins in 1984. (Both, courtesy of OHEKA Castle Hotel & Estate.)

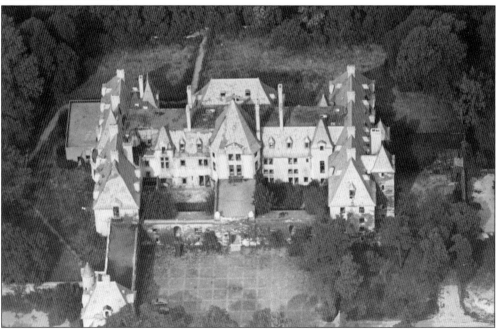

Six

RESTORATION
1984–1995

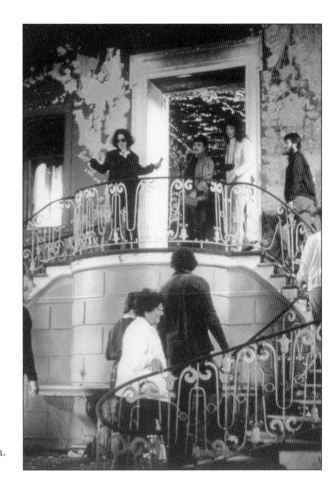

On August 14, 1984, in a daring and financially risky move, Gary Melius shelled out $1.5 million to purchase the ruinous shell of what was known as "the finest country house in America." The most expensive part of the project lay ahead: restoring the castle to its former glory. The restoration would take years and require the work of countless highly skilled craftsmen. (Courtesy of Joseph Silvestri.)

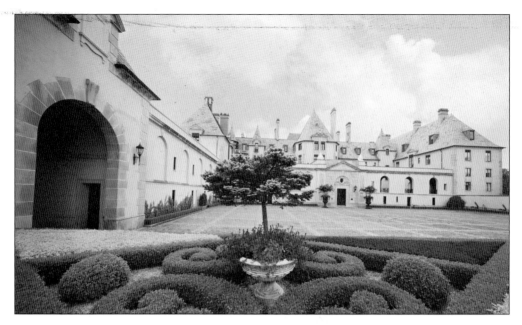

Gary Melius elected to bring back the name for Otto Kahn's mansion. Going forward, the old Eastern Military Academy would be known to the world as OHEKA Castle. When news of his purchase became public, the developer quipped that he had made the classic mistake in real estate—he had fallen in love with a property. Given the size of the task he now confronted, Melius had indeed invested himself in OHEKA, both financially and emotionally. Still, the town's decision to permit the redevelopment of condominiums with the community's support must have figured prominently into his plans. The restored courtyard is pictured here. (Above, courtesy of OHEKA Castle Hotel & Estate; below, courtesy of Elliott Kaufman Photography.)

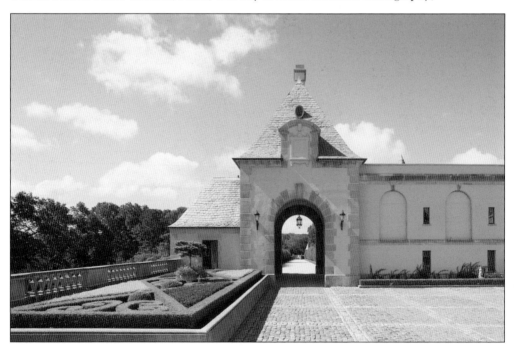

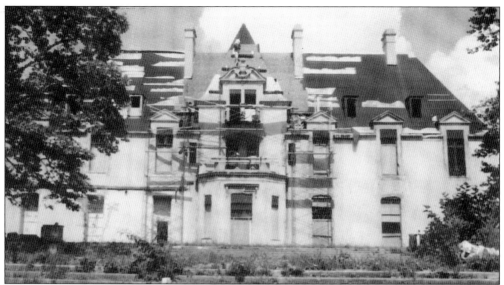

In the closing months of 1984, OHEKA's new owner continued to secure the building from vandals and from the elements. That winter, Gary Melius began the arduous task of planning every detail of the reconstruction with his staff. By the spring of 1985, he was ready to begin. What remained of the original slate roof tiles were reinstalled on OHEKA's front, back, and eastern roofs. For the west side facing the formal gardens, Melius used the same company, Rising & Nelson Slate, that had installed the original roof. The cost of the new slate was $81,000. In the photograph at right, the original roof has been replaced with new slate tiles. (Above, courtesy of Ellen Schaffer; right, courtesy of OHEKA Castle Hotel & Estate.)

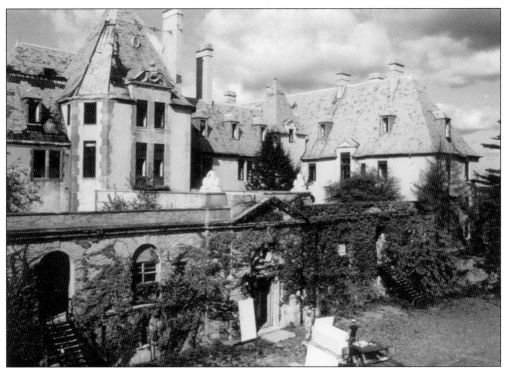

Shown here, the ivy and moss that had taken over the facade of the building was removed. OHEKA's exterior walls were sandblasted, and new stucco was applied. Overgrown weeds, bushes, and trees in OHEKA's courtyard and gatehouse areas were cleared away. Restoration of the remaining exterior walls with new stucco followed. The exterior work, including restoration of the roof and sealing up missing windows, skylights, and exterior entrances, had to come first. Missing windows and skylights had allowed rainwater to enter the building for years. Thousands of gallons of water, which firefighters had used to extinguish more than 100 fires that were set in the building over the previous five years, had also resulted in major damage. (Above, courtesy of OHEKA Castle Hotel & Estate; below, courtesy of Ellen Schaffer.)

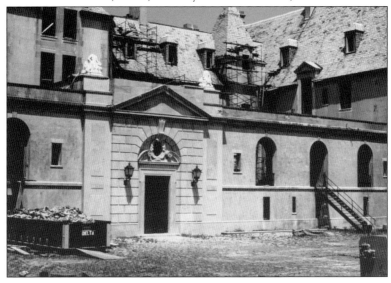

Scaffolding was erected along the western side of the building. What tiles remained of the original roof were removed and preserved. Each tile was taken in through window openings and stored. The wooden tongue-and-groove sheathing that covered the concrete roof structure was replaced and covered with tar paper. Then, new slate tiles were carefully installed. It would take two years alone to complete the roof at an estimated cost of $250,000. In 1986, once the major exterior work was complete, the enormous task of sandblasting OHEKA's interior walls began. Peeling paint had to be removed. The grand staircase is shown here, during and after restoration, with its marble steps, ornate wrought-iron railings, and limestone walls. (Right, courtesy of Ellen Schaffer; below, courtesy of Elliott Kaufman Photography.)

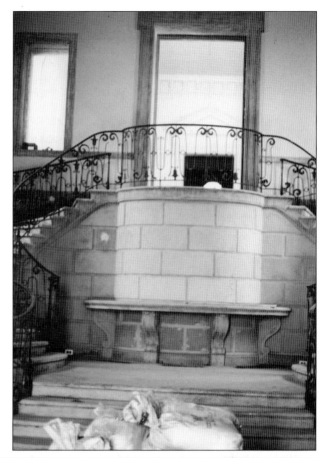

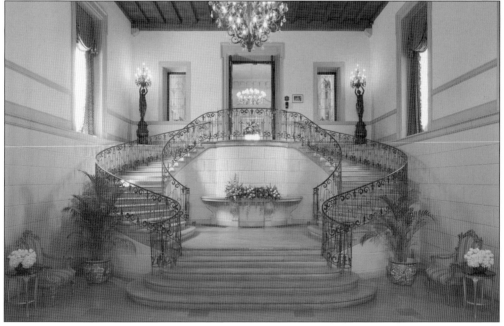

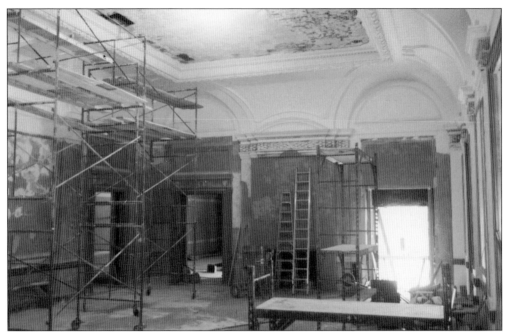

The Kahns' fire-blackened ballroom required the most extensive work. Its once beautiful French doors had provided easy access for vandals and arsonists. The plaster ceiling, walls, elaborate plaster moldings, and wooden floor had all been destroyed by water and fire. Scaffolding was erected to support the artisans who replaced all the damaged and missing plaster moldings and restored the ceilings and walls. The Kahns' ballroom, pictured, was among the most damaged rooms in the mansion because it was easily accessible to vandals and arsonists who continually created bonfires to keep warm in the winter. (Both, courtesy of Ellen Schaffer.)

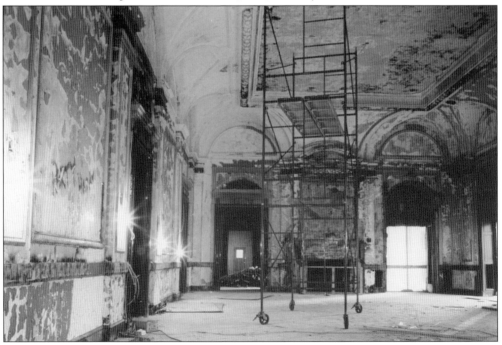

Using special rubber molds, workers replicated plaster moldings that had been destroyed or gone missing. In keeping with Gary Melius's firm desire for an authentic restoration, the original plasterwork was replicated in the ballroom and throughout the first floor of OHEKA. Amazingly, one of the 14 doors in the ballroom survived intact. Melius used the sample door to create duplicates that were placed throughout the room. For the exterior doors, three sets of custom-made replacement double doors with windows above were handcrafted and installed to replace those that were used as firewood for the hundreds of fires set in the ballroom alone. (Both, courtesy of Ellen Schaffer.)

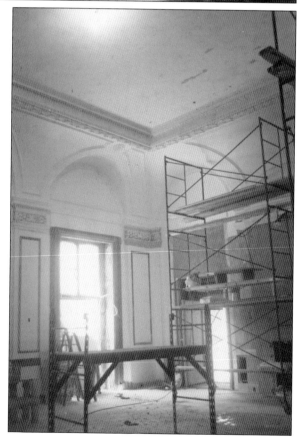

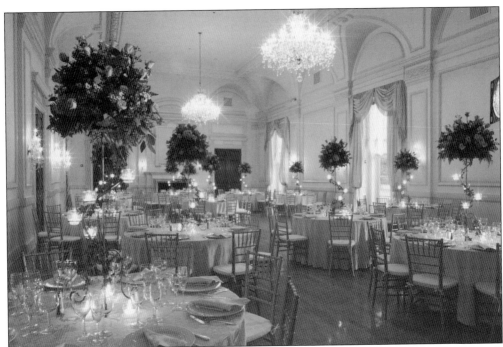

The ballroom, above, measuring 70 feet by 34 feet with a 23-foot-tall ceiling, was sandblasted. After the plasterwork and walls were reconstructed, the room was repainted. A new oak floor was installed. Two new crystal chandeliers and silver and crystal wall sconces completed the restoration. Otto Kahn's library, measuring 51 feet by 28 feet, was restored with the same authenticity. The ceiling, walls, and moldings were reconstructed using plaster to match the work ordered by Kahn. The oak floor was restored. The plaster walls were refinished, using the same *faux bois* (fake wood) technique that Kahn used to ensure a fireproof home. Only the bookshelves were re-created in wood. The restored library, below, achieved the original's look and feel. (Above, courtesy of OHEKA Castle Hotel & Estate; below, courtesy of Brett Matthews Photography.)

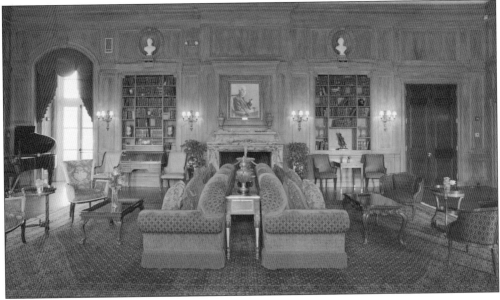

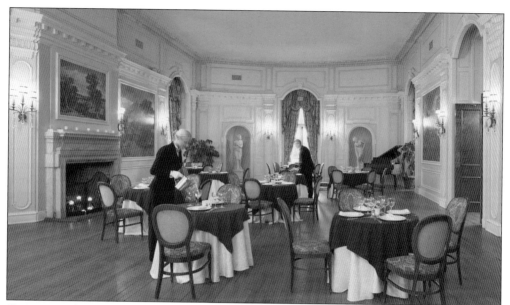

Once restored, OHEKA's formal dining room embodied the elegance intended by its original owners. The 54-foot-by-30-foot room was adorned with silk murals that closely resembled the originals featured in photographs provided by the Huntington Historical Society. The decorative plaster crown molding was restored, and the room was painted an eggshell white. The same techniques used to restore the ballroom were used in the Kahns' formal dining room. The original oak flooring was restored, but the walls and ceilings had to be re-created. OHEKA's reception hall, measuring 36 feet by 27 feet with an 18-foot ceiling, was restored using Delano & Aldrich's famous concept of clarity and simplicity, strongly reflecting the architects' French training. (Above, courtesy of Elliott Kaufman Photography; below, courtesy of Ellen Schaffer.)

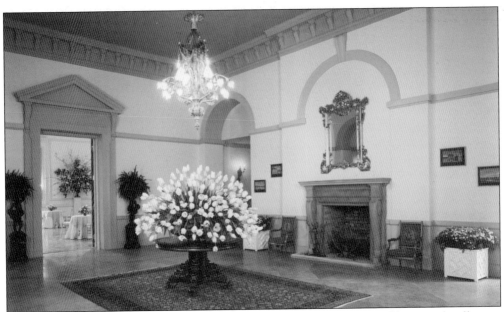

The reception hall, above, was sandblasted clean and its plaster ceiling, moldings, and walls were reconstructed. The ceiling was hand-painted with white clouds floating beneath a blue sky. The limestone mantle (one of a few remaining from the original 39) was restored. OHEKA's galleries and hallways that housed the Kahns' art collection were restored to their original magnificence. Antique furniture, fixtures, and oriental carpets were purchased at estate auctions to furnish the ballroom, formal dining room, library, reception hall, galleries, and hallways. A total of 400 windows and doors were replaced with custom-fashioned replicas of the originals. During the spring of 2003, the Chaplin Room, below, was completed as Gary Melius's tribute to Charlie Chaplin, who had been a guest of Otto Kahn in the mansion's Cold Spring Harbor days. (Both, courtesy of OHEKA Castle Hotel & Estate.)

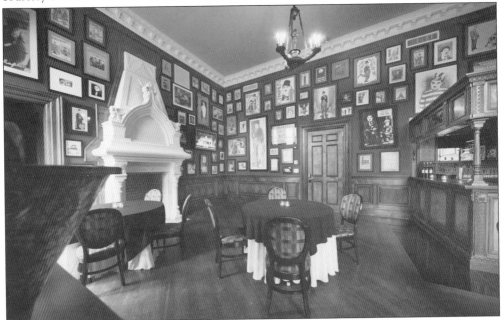

This portrait of Addie Kahn in her sitting room was provided by her granddaughter Virginia Fortune Ogilvy, the Countess of Airlie, who served as the senior lady-in-waiting to Queen Elizabeth. Addie insisted upon the formalities to which she was accustomed at her Fifth Avenue, New York City residence. Addie's elegantly appointed, wood-paneled sitting room, adjacent to her husband's library, overlooked the formal gardens that the Olmsted Brothers designed with her help. Addie's restored sitting room is shown below. (Right, courtesy of Virginia Fortune Ogilvy; below, courtesy of OHEKA Castle Hotel & Estate.)

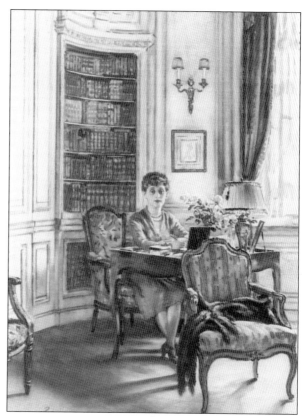

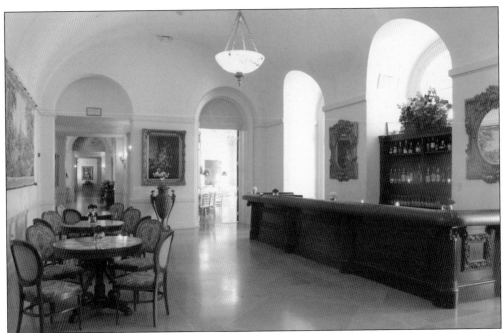

The bar and lounge area, shown above in their fully restored state, once housed the Kahns' extensive art collection. Today, this area of the mansion is a gathering place for guests of weddings and other social events hosted at the castle. Below, the restored loggia located just outside of the bar and lounge area overlooks Cold Spring Harbor to the north. The wrought-iron light fixture is one of only two that remain from the original mansion. The other original fixture is located in the entrance hall above the grand staircase. (Above, courtesy of OHEKA Castle Hotel & Estate; below, courtesy of Elliott Kaufman Photography.)

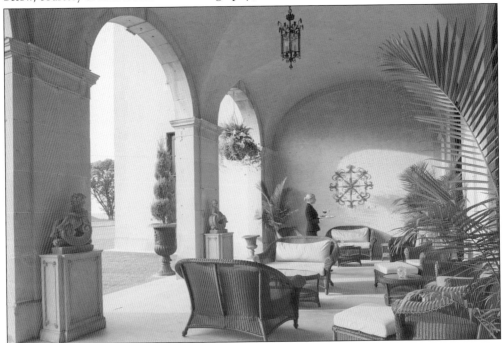

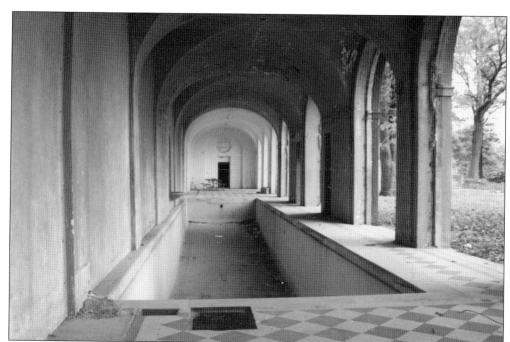

Like many other areas of OHEKA, Otto Kahn's 75-foot indoor swimming pool was altered by Eastern Military Academy. Painted in a military blue, the pool was covered before workers sandblasted and renovated the entire area. The blue walls and mildewed black-and-white tiled floor were then carefully restored to their original appearance. Replacement Palladian window units filled the archways. This area was originally planned to house an indoor orangery, while the pool was to be located just outside. With financial pressures to curtail the expense of lavish amenities during wartime, however, the Kahns directed their designers to convert the orangery to an indoor lap pool and cancelled their plans for an outdoor pool. (Both, courtesy of Ellen Schaffer.)

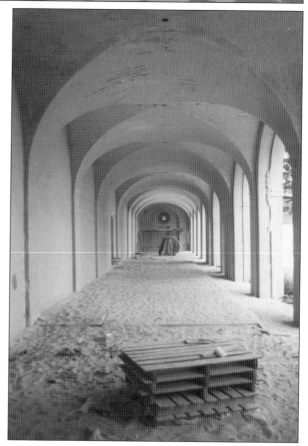

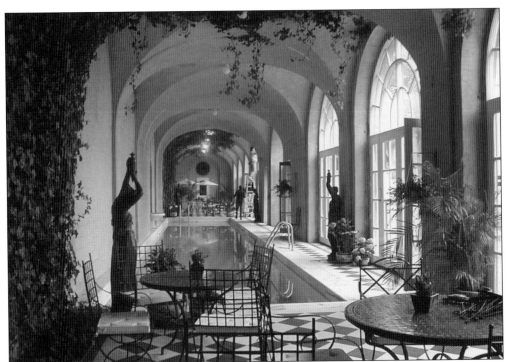

Today, the mansion's indoor lap pool has attracted the interest of the filmmaking and still-photography industries. This photograph shows the restored pool area being prepared for a scene in *The Emperor's Club*, filmed at OHEKA in 2002. In the photograph below, OHEKA's once majestic and carefully tended landscape appears in complete ruin. Trees, bushes, lawns, and bridle paths had become wildly overgrown. The restored grounds reflected the grace and beauty first envisioned by the Kahns' architects, Delano & Aldrich, and landscape designers, the Olmsted Brothers. (Above, courtesy of Roger Diller; below, courtesy of Ellen Schaffer.)

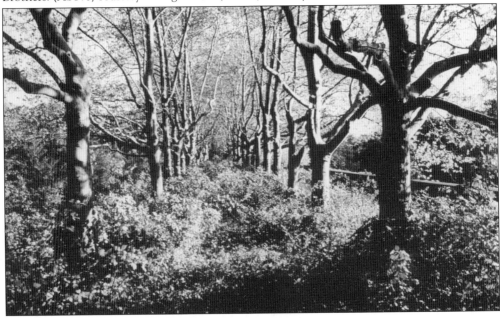

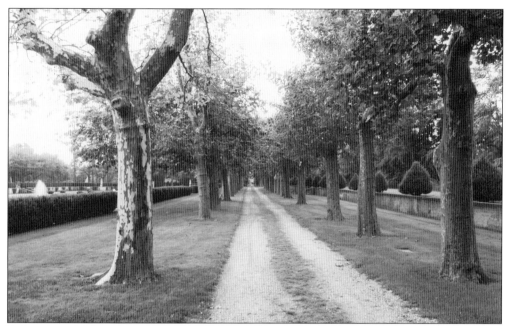

Before Gary Melius acquired OHEKA, four of the eight reflecting pools had been filled in by Eastern Military Academy for military tank training. All of the fountains and statuary had been removed. Hoping to salvage the four reflecting pools, Melius ordered the foundations excavated. But inspections showed that the structures could not be saved. Despite the steep price tag, he opted to replace eight of the pools' foundations and three of the fountain's foundations. He also decided to replicate the original gardens. Copies of the Olmsted Brothers' original plans were obtained from the firm's archives so that the work on the reflecting pools, fountains, and walkways would be historically correct. A restored walking path, above, and what was left of the reflecting pools, below, are pictured here at the time Melius acquired OHEKA. (Above, courtesy of Infinity Photography; below, courtesy of OHEKA Castle Hotel & Estate.)

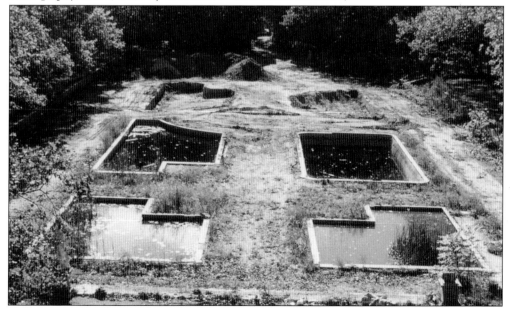

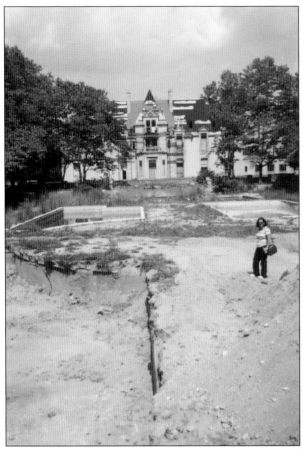

In 1985, Ellen Schaffer, shown at left, witnessed both the new roof being installed on OHEKA's west side as well as the excavation of buried and hopelessly damaged original reflecting pool foundations. By this time, dozens of workers were removing debris and excavating the area of the formal gardens to remove the crumbling foundations. This part of the restoration took nearly a year. Little by little, the area began to resemble what was once the focal point of OHEKA's formal gardens. The restored pools and fountains are shown below. Afterward, new plumbing was installed throughout the area for the water features. New boxwood plantings, replacement statuary reminiscent of the originals, and sod completed this initial phase of the formal gardens restoration. (Both, courtesy of Ellen Schaffer.)

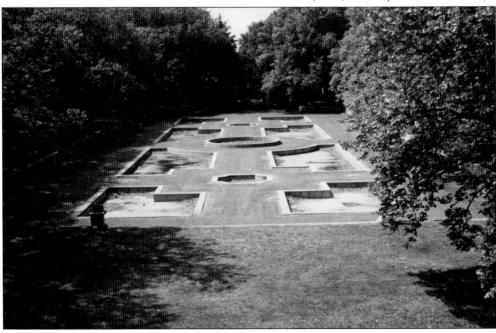

These images reflect the West Gate driveway and formal gardens after restoration. Five hundred mature cedars were planted to flank the entrance drive as the originals had been removed for tank maneuvers in the days of Eastern Military Academy. In the formal gardens, the surrounding Sycamore London Planes trees were pruned to encourage lower branch revival. Later, dozens more were added to replace missing trees. Custom-made coping created a finished edge for each pool and fountain. Walkways were redone in white gravel to resemble the original paths around the pools. Larger boxwood plantings replaced smaller ones. Restoration of the six staircases began. Years later, Friends of OHEKA purchased and donated two original statues, known as "the Tritons," which had graced the formal gardens 80 years earlier. (Above, courtesy of Elliott Kaufman Photography; below, courtesy of Infinity Photography.)

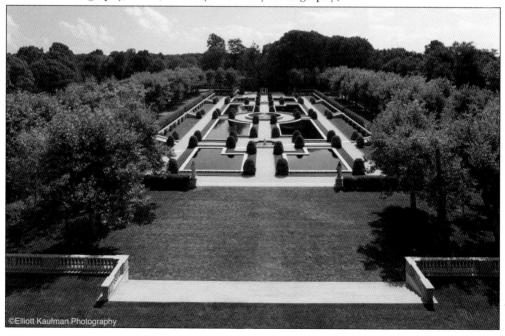

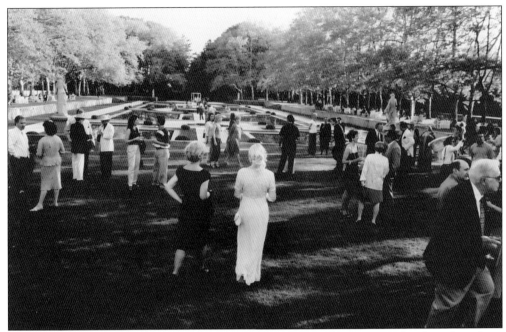

Pictured above in 2001, Friends of OHEKA held its first garden party in the formal gardens. Shortly before the party, Gary Melius completed the restoration of the staircases connecting the upper and lower levels of the gardens. The setting was perfect for the first garden party at OHEKA and showcased the completed restoration of OHEKA's formal gardens. Prior to this time, the only individuals who had seen the restored formal gardens were private guests of OHEKA. With the advent of the 2001 garden party, hundreds of people from the general public were able to enjoy the breathtaking beauty of OHEKA's newly restored gardens. (Above, courtesy of Jo-Von Photography; below, courtesy of Infinity Photography.)

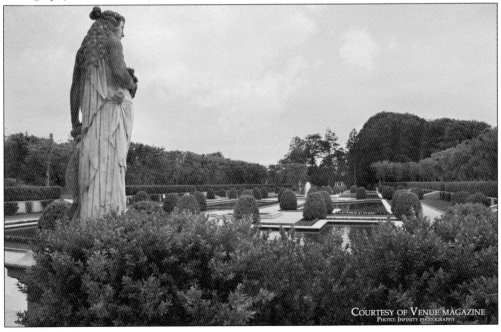

COURTESY OF VENUE MAGAZINE
PHOTO: INFINITY PHOTOGRAPHY

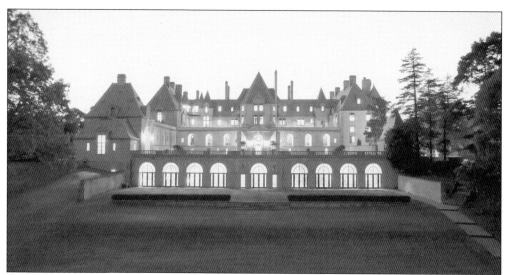

OHEKA was beginning to shine once again, but the work was far from complete. Depicted below, the Kahns' original statues remained beheaded by vandals as a reminder of earlier days. By this point, Gary Melius had sunk $10 million into a project that was less than a quarter complete. Amid continuing financial pressures and an uncertain market for luxury condominiums in 1987, Melius was forced to place OHEKA up for sale. On February 21, 1989, Nihon Sangyo Co. Ltd. of Tokyo took title of OHEKA for $22.5 million. It had no immediate plans to use or visit the property other than include it in its portfolio of worldwide real estate holdings. (Both, courtesy of OHEKA Castle Hotel & Estate.)

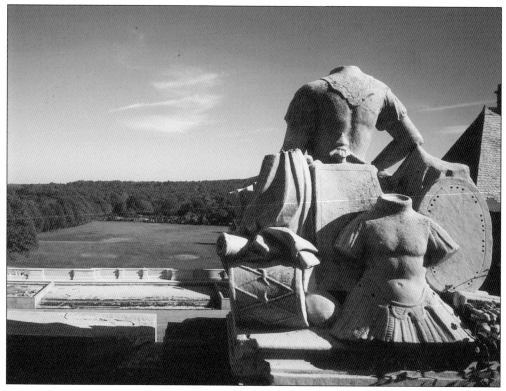

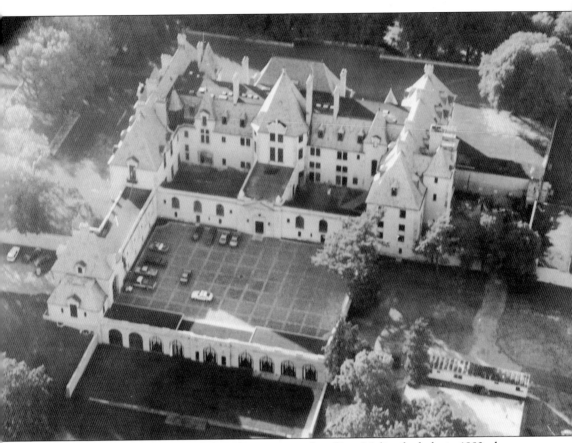

In a surprising turn of events, Nihon Sangyo turned to Gary Melius for help in 1993, the same year this aerial photograph was taken. Since parting with the building, Melius had been providing the firm with updates on OHEKA's state of affairs along with recommendations. Vandalism and floods had once again returned, destroying much of what Melius had earlier restored. Melius leased OHEKA with renewed determination to complete the restoration he had begun a decade earlier. Later, in 2003, he would purchase back OHEKA from the Japanese firm. After watching the empty castle once again succumb to vandalism and deterioration, neighbors quickly spread the good news that Gary Melius had returned. And so, the Long Island developer resumed his place at OHEKA to finish what he had started. (Courtesy of OHEKA Castle Hotel & Estate.)

Seven

FRIENDS TO THE RESCUE
1996–1997

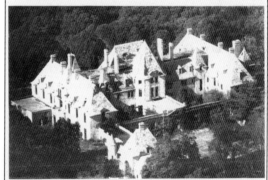

OHEKA Castle has a glorious past.

You can be a part of its future.

Enrico Caruso sang in its great ballroom. Arturo Toscanini lifted his baton to its soaring ceilings. Orson Welles used its magnificent edifice for "Citizen Kane." Heads of state, royalty and some of America's most notable families graced its luxurious guest rooms. *The New York Times* described it as the "finest country estate in America."

OHEKA Castle, completed in 1917 by banker and financier Otto Herman Kahn, stands majestically in Huntington's Cold Spring Hills as the second largest private home (109,000 sq. ft.) in the United States. OHEKA is second in size only to Biltmore in North Carolina (175,000 sq. ft.). At 60,000 sq. ft., San Simeon's Hearst Castle cannot compare to the enormity of OHEKA.

Homes of this size, historic value and architectural distinction come along once in a millennium. Biltmore, OHEKA and Hearst Castles are no longer homes to the rich and famous, but memorials of a bygone era. Their survival is a tribute to the people who had the foresight and determination to preserve them for us and for future generations. Yesterday's challenges, including the vandalism and ruin of OHEKA, have been met with the support of the community and the Town of Huntington. You can help us meet today's challenge to allow OHEKA to become a useful, purposeful building so that it may continue its great legacy.

Join "Friends of OHEKA." Call 367-2570.

By 1994, Gary Melius began hosting banquets at the mansion. Those who rented the mansion were thrilled by OHEKA's first-floor spaces with their 1920s flair. The revenue derived from these functions helped to defray a portion of the enormous maintenance and restoration expenses; the annual cost for taxes and maintenance alone totaled $600,000. This piece is from OHEKA's 1996 advertising campaign. (Courtesy of Joan Cergol.)

Oheka Launches 'Awareness' Campaign

Move comes after appeals court refuses Oheka stay; settlement talks are rumored

By A. Anthony Miller and George Wallace

Proponents of a catering facility at America's second largest private residence, Oheka Castle, have this week launched what they term is a "public awareness initiative" which they hope will alert local residents to the treasure which they say the castle represents. The move, which comes as a second court has ordered that Oheka be closed due to outstanding violations of fire codes, began this week as Oheka representative Joan Cergol extended an open invitation to town officials and residents to walk through the castle.

"*Seeing is believing* are our opening words," said Cergol, representing Oheka Management's communications director. The purpose of the walk-through, she noted, is "to dispel any concerns with respect to the building's safety."

The Appellate Division of the state Supreme Court, in a brief order dated last Thursday, July 18, denied a request to allow the castle to continue operating while that court considers an appeal of Judge Howard Berler's July 2 order. Berler had acted on a request by the town attorney's office, which asked that the castle be shut until it complies with town and state fire codes and resolves outstanding violations. The town's efforts had been ongoing since last year.

"Oheka Management has invested over a half-million dollars in state-of-the-art fire equipment," said Cergol. "Oheka is equipped with heat, smoke and fire sensors, automatic sprinkler systems, emergency exit doors and signs, fire stops, strobe lights as well as portable fire extinguishers located conspicuously throughout the concrete and steel-constructed building. It's almost laughable that anyone could call Oheka a fire trap. I can't think of anywhere I'd rather be, including my own home, should fire break out."

She extended Oheka Management's invitation to residents to see the safety system themselves, by appointment.

The public awareness initiative takes place as court consideration of the historic castle's operational fate continued last week. Arthur Goldstein, the attorney for Oheka operator Gary Melius, and Anthony A. Capetola, the lawyer who represents the caterer, Carlton Gourmet, had asked the four-judge appeals court to delay Berler's order while they appealed it. Goldstein also asked that the appellate court expedite decision on the appeal itself. Both requests were denied in a brief order made public Friday.

Assistant Town Attorney Andrew Levitt said this week that the town served a copy of the Appellate Division order Friday on Goldstein's office in person and on Capetola by mail. Such service is legal notice to the castle operator, Gary Melius. But despite that service and notice, some neighbors of the castle reported that a party was held on the property Saturday.

Levitt said, "We're investigating whether a party took place at Oheka Castle and from the determination and facts presented to us, we will take the appropriate action." Referring to a list of upcoming weddings set for the castle, including ones this Friday and again on Sunday, Levitt said that town inspectors would be watching the castle. "We have the right to inspect under the Oct. 27, 1995, order signed by Justice Patrick Henry," he said.

If events are held at the castle, the town could ask that the castle operator be held in contempt of court. Each contempt finding is punishable by a fine and/or jail term of up to 30 days. But at press time, sources said that the town and the castle operator were engaged in discussions that could settle the controversy and keep the castle operational.

The court's July 18 decision made no mention of an argument raised before Berler by Northport attorney John Flanagan Jr., who is representing neighbors of the castle who are opposed to its use as a catering facility. Flanagan argued that regardless of fire code violations, the castle does not have a valid certificate of occupancy.

The contentions of those residents are at odds with a position of strong support for an appropriate use of the facility by Melius which has been maintained by the Cold Spring Hills Civic Association for some time now.

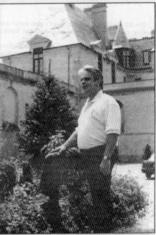

Gary Melius is struggling to keep catering operations going at Oheka. The castle in Cold Spring Hills is the subject of a court fight that has reached the Appellate Division.
Long Islander File Photo

According to Joe Colacicco of that group, their belief is that Gary Melius for the past 12 or 13 years has enhanced the castle and the quality of life for those around the castle from a previous condition when vandalism and loitering were a serious menace to the peace and tranquility of the community.

Banquet affairs helped finance Gary Melius's restoration plan, with the exception of one problem: OHEKA was not zoned for a commercial banquet business. He knew he was in a zoning catch-22 and was determined to resolve it. At the same time, he was sensitive to the needs of his neighbors, who (thus far) energetically supported his redevelopment plans. Melius had promised that he would not seek a commercial rezoning of the property, and he knew that going back on that promise could destroy the goodwill that he had established. With that in mind, he asked his attorney to find some other remedy. Despite the significant challenge ahead, in 1996 he and his attorney pressed forward with a groundbreaking zoning proposal that would give the town board the right to permit adaptive reuses of an historic building—such as a banquet hall at OHEKA. The first step for Gary and his team was to ask the town board to consider the adoption of the legislation. (Courtesy of *Long Islander*.)

The Long-Islander.

Founded by
Walt Whitman in 1838

Nobody Covers Huntington News Better Than The Long Islander
Our 159th Year Serving Huntington Township

Year, No. 20 Thursday, October 24, 1996 48 Pages, 75 Cents

Scouts Tour Oheka

"Somebody *lives* here?" inquired 7-year old Mary Finnegan of Huntington, as she stared at the second largest private residence in America, OHEKA Castle in Cold Spring Hills.

"No," replied Sasha Odiamar, also of Huntington. "This has got to be the castle where Cinderella went to the ball!"

Gasps and wows were the next and only sounds to be heard as 12 seven year-old girls of Brownie Troop 127 from Saint Patrick's School in Huntington entered OHEKA Castle for the first time last week. They were the first Girl Scouts to visit the castle as part of a public awareness campaign. Many more scouts and other children will follow during this school year to learn about the life and times of the castle's builder and owner, financier Otto Kahn, and how and why a *castle* came to be in Huntington.

Troop co-leaders Geri O'Brien and Maddie Hackett, assisted by Joanne Finnegan, encouraged questions during the tour provided by OHEKA commu-

nications director Joan Cergol. One subject of great interest was the Kahn children. Gilbert, Roger, Maud and Margaret Kahn were the envy of these girls.

"They were so lucky to live here!" beamed Meaghan Sullivan of Huntington. "Can you show us the playroom?" asked Ariana Knutson.

What these children did not want to hear was that Gilbert, Roger, Maud and Margaret Kahn were young adults by the time they came to spend summers in Cold Spring Hills, so there was no playroom. But there was a fully staffed nursery for the children of guests, along with 443 acres of property with stables, horses, race tracks and an indoor pool. Indoors, OHEKA offered 126 rooms to roam, and a servant for each (126 in all).

After a tour of the ballroom, the grounds, formal gardens and reflecting pools, the Brownies stopped for a rest at the Kahn's garden patio to work on posters depicting OHEKA.

Brownie Troop 127 members, from left, front row, are: Alexandra (Sasha) Odiamar, Cl tine Roach, Mary Christine O'Brien. Middle row: Katherine Hackett, Caitlin Josephs, S Wilcox, Shannon Rendall and Meaghan Rehm. Back row: Meaghan Sullivan, Emily Cer Mary Finnegan and Ariana Knutson.

If the town board enacted the legislation, adaptive reuses could be established for OHEKA. There was no doubt that Melius and his team would face a difficult battle. But as preparations were underway for OHEKA's annual July 4th party, the castle was visited by town code enforcement officers who issued a summons for conducting commercial activity on residential property. Officials ordered that the banquets at OHEKA be ceased. There were several events booked on OHEKA's calendar, including a wedding. All of these parties would have to be canceled. While the neighbors who supported his work far outnumbered those who did not, the vocal minority was well organized. They had already succeeded in pressuring town officials into taking action. It was time to garner town-wide public support. Melius recruited Joan Cergol, a public relations professional, to create an awareness campaign. The campaign to "Save the Castle" included a tour program for adults and children. (Courtesy of *Long Islander*.)

81

Remembering Otto H. Kahn

Meet Otto H. Kahn, a prominent resident of Huntington's past. Otto Kahn earned his worldwide acclaim and great wealth through his expertise in the world of high finance, railroad reorganization, and as one of America's greatest patrons of the arts.

Although Otto Kahn owned a number of major properties across the United States and overseas, he did not fulfill his ideal of the ultimate estate until his Huntington mansion was completed in 1917. So proud of his great building achievement, Kahn used his own initials to name his new residence: Otto H Ermann KAhn.

It was in 1914 that Otto Kahn first came to Long Island in search of a site on which to build the magnificent edifice of his dreams. After learning that the highest rise of land had already been purchased, Kahn acquired the 443-acre tract of land in Huntington's Cold Spring Hills for one million dollars, and opted to build a mountain of his own. He retained as his architect William Adams Delano of the famed firm of Delano and Aldrich, and for the landscaping, the Olmsted Brothers of Boston, whose founder landscaped New York's Central Park and Washington's Capitol grounds.

En route. (Courtesy of Mrs. John Barry Ryan)

Three years later, Kahn's dream was realized with the completion of the 127-room chateau, patterned after the palace of Fontainbleau and classic French castles. For a total of nine million dollars, Kahn's palatial estate included a dazzling ballroom, formal dining room seating 200, sweeping horseshoe staircase, breathtaking library, billiards room, ten-car garage, stables, greenhouses, pools, tennis courts, an eighteen-hole golf course and densely flowered gardens complete with reflecting pools and statuary. Otto Kahn and his wife, Addie, employed 126 servants to tend to their four children and the domestic duties associated with the upkeep of OHEKA. It was at OHEKA that Otto Kahn found retreat from the rigors of the complex business world.

Born in Mannheim, Germany in 1867 to a family of wealth and culture, Otto Kahn was directed at an early age to a career in banking. He move to New York City in 1893 to join the major banking firm of Kuhn, Loeb & Company. Eventually becoming the star partner of Kuhn, Loeb, Otto Kah rivaled J.P. Morgan as the wizard banker of his era and became a preeminent authority in the highly competitive world of railroad financing.

Among Otto Kahn's greatest loves was the opera. In 1903, he bought an interest in the Metropolitan Opera, and four years later, to save it fro collapse, joined William K. Vanderbilt in taking over complete ownership. Kahn later bought out Vanderbilt's ownership, and upon his death, owne nearly all of the stock in the company. In addition to contributing heavily to the support of the opera, he brought Arturo Toscanini from Milan's L Scala to conduct the Met's orchestra. Otto Kahn was chairman of the Met from 1911 until 1918 and then president until 1931. He also gave generous to countless museums, theaters, schools, orchestras and other cultural and educational institutions throughout the country.

Otto Kahn died at the age of 67 in New York City on March 29, 1934. Funeral services were held in the music room he so loved at OHEK/ after which he was laid to rest in a family plot in Cold Spring Harbor. But, Otto Kahn's storybook castle, OHEKA, will forever remain an historic landmar and monument to one man's lifetime of contributions to the business world, arts and American society. ❖

This glimpse of local history was brought to you by **Friends of OHEKA**, a non-profit organization in formation dedicated to the preservation of Huntington's OHEKA Castle (Otto H. Kahn mansion) and its history. For more information, and/or to join Friends of OHEKA call 367-2570.

In reviewing the large volume of OHEKA-related materials in preparation for the task ahead, Cergol identified an essential goal to elevate the perception of OHEKA as a landmark historic building with an important history. Cergol suggested inviting residents to see and experience the building for themselves. Hence, an invitation to visit OHEKA was the theme of the first installment of a 16-week advertising campaign. The introductory advertisement, entitled "Seeing is believing," appeared in three local newspapers. It spoke with incredulity that OHEKA, with its size and historic stature, could remain little known to the public. Each advertisement in the series ended with a call to join Friends of OHEKA, Inc., an organization formed in August 1996 to save the landmark historic building. Shown here is an installment from OHEKA's 1996 advertising campaign featuring Otto Kahn. (Courtesy of Joan Cergol.)

Remembering Addie Kahn

Meet Addie Kahn, wife of Otto H. Kahn and "First Lady" of OHEKA. Born in 1876 to a family of wealth, prestige and culture, Addie indeed held her own as a lady of superior intellect, artistic talent, charm and social grace.

Otto met Addie when he came to the United States in 1893 to take his place on Wall Street. Kahn's brilliance, continental demeanor, striking good looks and reputation as a gentleman charmed the young Addie. Then only seventeen, Addie was the daughter of Abraham Wolff, a senior partner at the banking firm of Kuhn, Loeb & Co. The elder Wolff took an immediate liking to Otto Kahn, who displayed great promise as both a future son-in-law and banking icon. And so it was Abraham Wolff who urged Kahn to take his youngest daughter in marriage, and leave the banking firm of Speyer & Company to join Kuhn, Loeb as partner. Marriage to the beautiful Addie Wolff *and* partnership with the second largest banking firm on Wall Street was an opportunity not to be passed over by Otto Kahn.

Otto and Addie were married on January 8, 1896 at Abraham Wolff's New York City townhouse. Wolff promised to reserve a desk for his new son-in-law upon the couple's return from a year-long European honeymoon. Otto was anxious to introduce his new bride to the art, culture and history of his homeland. It was during their honeymoon that Otto and Addie acquired some of the most valuable art treasures that would eventually be housed at OHEKA.

A gifted amateur landscape designer, Addie directed the development of landscaping at OHEKA carried out by the famous Olmsted Brothers of Boston. So pleased with the magnificent outcome of the formal gardens and reflecting pools, Addie saw to it that her private sitting room and master bedroom suite overlooked her work. Addie took great pride in using her Huntington mansion for social and business engagements, including full-scale dinner parties seating 200 in the formal dining room. Each guest would have his or her own personal servant for the evening.

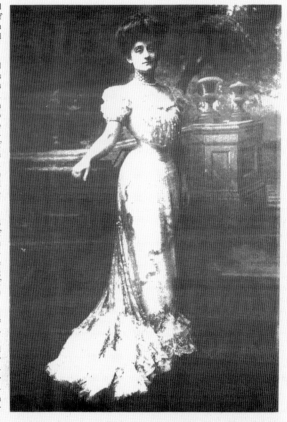

During the first eleven years of their marriage, Addie and Otto produced four children, Maud, Margaret, Gilbert and Roger, who enjoyed their summers at OHEKA. Much to the delight of their mother, Maud and Roger used the formal gardens at OHEKA as a backdrop for their wedding ceremonies, followed by lavish receptions on the entire first floor of the enormous mansion. Considered a major social news event, Maud's June 15, 1920 wedding at OHEKA was captured on newsreel. Maud married an officer of the Scots Guard attached to the British embassy in Washington.

Like her husband, Addie Kahn died of a heart attack. On May 24, 1949, following a brief ceremony in the chapel of the Memorial Cemetery in Cold Spring Harbor, Addie's ashes were buried in the family plot beside her beloved husband Otto Kahn.

This glimpse of local history was brought to you by **Friends of OHEKA, Inc.**, a non-profit organization dedicated to the preservation of Huntington's OHEKA Castle (Otto H. Kahn mansion) and its history. For more information, and/or to join Friends of OHEKA, call 367-2570.

Many who visited OHEKA could not believe that such a place even existed in their town and knew nothing about its history. Many were awestruck by the mansion, and support of Friends of OHEKA was growing. In response to the support OHEKA was garnering through its public awareness campaign, the handful of opposing residents stepped up their communications. On September 24, 1996, the town board held a public hearing to consider comment on the proposed legislation. Hundreds turned out to support Melius's proposal for a Special Historic Building Overlay District. Friends of OHEKA had successfully established the groundswell of support needed to encourage the town board to approve the legislation. In October, the town board adopted the new legislation. An installment from OHEKA's 1996 advertising campaign featuring Addie Kahn is pictured here. (Courtesy of Joan Cergol.)

JULY 13, 1997

Produced by this week's staff: Ellen Keuling's fifth-grade class
Chestnut Hill Elementary School, Dix Hills

PLACES TO VISIT

Oheka Castle

By Janelle Wong, Jamie Schulman and Marni Krakauer
Kidsday Staff Reporters

used for charity events and special parties like weddings, and, starting again in the fall, for public tours.

We were recently given a special private tour of the castle and we thought it was amazing. If you'd like to schedule a tour or a special event call 516-367-2570.

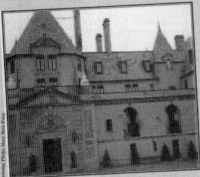

Newsday Photo: Mary Beth Foley

Front view of Oheka Castle

Did you know that there is a huge castle in Huntington? Well, there is. It is called **Oheka Castle** and it was built in 1917 by a millionaire named Otto Hermann Kahn. It is the largest home ever built in New York State and the second largest home ever built in America — and it was just the Kahn family's summer vacation home! With 126 rooms, it is twice the size of The White House in Washington, D.C.

Originally the castle was part of a 443-acre estate that had an 18-hole golf course, horse stables, greenhouses, a farm, tennis courts, airstrip and race track. After Kahn's death in 1934, the castle wasn't used much by his family. It was sold and later used for a boy's military academy and other things. In 1978 it was closed, and for six years after it was vandalized.

In 1984, a Long Island developer named Gary Melius bought Oheka Castle and began restoring it. Today it is

Did You Know?

Although there weren't any knights in shining armor living at Oheka Castle, here are some interesting facts about medieval castles and the knights who protected them:

1. A castle was the home of a wealthy person, such as a lord or the king. The first castles were probably built in France in the ninth or 10th Century to protect wealthy families from their enemies.

2. It took a lot of work before someone became a knight. When a boy was about 7 years old, he would be sent to live in a castle and serve as a page. He would learn the basics, such as how to behave and how to ride a horse. When he was about 14, he would become a squire. He would learn how to handle weapons, and most importantly, become a knight's personal helper. One of his duties as a squire would be to help his knight put on his armor. If he was a successful squire, he would be knighted when he was about 21, and then he would be ready for battle.

(Sources: "The Ultimate Castle & Knight Sticker Book, DK Publishing, $6.95, and "The Knight's Handbook" by Christopher Gravett, Cobblehill Book/Penguin Publishing, $13.99.)

In January 1997, Gary Melius submitted his application seeking three adaptive reuses as a banquet hall, a designer show house, and a luxury health spa. That month, Friends of OHEKA held its first annual meeting. When the meeting ended and the last guests were leaving, an elegant woman, accompanied by a young man, arrived at the castle unannounced. The visitor identified herself simply as "Ginnie." She later shared that she was a granddaughter of Otto and Addie Kahn and was currently living in England. Beau Ryan, the young man accompanying Ginnie, was her nephew. Later, it was learned that she also held the title Lady Airlie and served as the senior lady-in-waiting to the Queen of England. Ginnie and Ryan explained that they had just come from St. John's Memorial Cemetery in nearby Laurel Hollow where they were visiting the Kahn family gravesite. On the spur of the moment, they had decided to stop in on the former Long Island country house of their relatives. (Courtesy of *Newsday*.)

84

Cold Spring Hills:
Otto Kahn's Granddaughter Visits Oheka

By A. Anthony Miller

They couldn't have been more surprised at Oheka Castle if Otto Herman Kahn himself walked in.

A recent visit to the castle by the granddaughter and great grandson of Otto H. Kahn added special significance to an already important historic day for the Friends of Oheka. The 300-plus member organization, committed to the preservation of the landmark building, had just concluded its inaugural annual meeting when the surprise visitors arrived at the castle doors.

On hand to welcome the Kahn descendants in the entry foyer — where Otto Kahn himself once greeted notable guests — were castle operator Gary Melius and his daughter, Kelly. The Meliuses were stunned and thrilled to learn that the attractive and well spoken lady — who identified herself simply as "Ginnie" — and her nephew and escort, Beau Ryan, were members of the Kahn Family.

The two said they were in the area and had decided, on the spur of the moment to stop by to see if they could visit the Long Island estate their ancestor had built some 80 years earlier.

Beau Ryan of New York City and his aunt, visiting New York from her London home, had arrived from St. John's Memorial Cemetery in nearby Laurel Hollow, where they had visited the Kahn family plot. That's where Otto and his wife, Addie, are buried, along with Ginnie's parents and Beau's grandparents, Margaret D. Ryan and John Barry Ryan II, among other family members.

Ginnie Ryan's last recollection of Oheka dated to when she was a young teenager, visiting the then-sold off estate with her mother. Ginnie recalled that her mother was saddened to see that the building had fallen into disrepair and had been renamed "Sanita" for its use as a retreat for New York City Sanitation workers. Beau Ryan, although living not 40 miles away, had never been to Oheka.

Ginnie Ryan, granddaughter of Otto Herman Kahn (fourth from left) poses on her visit to Oheka with, from left, Emily DeGregorio, Ellen Schaffer, Edward Owen, Beau Ryan, Kelly and Gary Melius, Robert DeGregorio and Joan Cergol.

Photo courtesy Friends of Oheka

responsibilities are accompanying the queen on foreign tours and greeting incoming heads of state and royalty from other countries. The title of Lady in Waiting comes by personal appointment of the monarch.

Also present to meet the countess and Beau Ryan were Huntington attorney Ted Owen, just re-elected president of Friends of Oheka; Joan Cergol, communications director for the castle; and directors Emily DeGregorio and Robert DeGregorio, all of Huntington. The visitors seemed impressed with the restoration efforts to date and were pleased to learn of plans for Oheka's full restoration.

Overwhelmed by the enormity and beauty of the building, the countess remarked that Oheka was much larger than she had recalled. The countess was on her way home to London that day, and as a parting gift, was given a book depicting the history and restoration of her grandfather's Long Island home titled, "Raising a Fallen Treasure," by Robert King.

of her father commuting to Wall Street from the bay on one of his boats during the week. Of her brother Roger (Pips), flying acrobatics over the house before landing on the private landing strip my grandfather had built. Sadly, my grandfather died when I was only 1, so I never had the fun or excitement of knowing this remarkable and hugely generous man.

"It was a rare treat for me to have had the opportunity of visiting the great house where my mother grew up and to find people so interested in helping to preserve a remarkable piece of history. Thank you for that." — Ginnie

Otto Kahn married Addie Wolff in New York City on January 10, 1896. All four of the couple's children, Maud, Margaret, Gilbert and Roger, are deceased. Margaret nicknamed "Nin" by her father, married John Barry Ryan II, a Newark Ledger reporter, on February 9, 1928. Margaret and Ryan had two children, John Barry Ryan III, who presently lives in New York City and Virginia (Ginnie), who now lives in England with her husband, the Earl of Airlee, six children and 11 grandchildren.

Elected Directors

At that inaugural meeting of Sunday, January 19, the Friends of Oheka elected to its board of directors the following people, most of whom reside in the town of Huntington: Elected to a three year term were Debra Bettis, Elaine Capobianco, Joan Cergol, Joseph Colaccico, Dennis Garetano, Matt Harris, Lawrence Kushnick, Edward Owen, Devon Postiglione, Ellen Schaffer, Alissa Taff and Henry Zotti.

Elected to a two year term were Linda Bay, William Bohn, Thomas Case, Pasquale Curcio, Emily DeGregorio, Dina Foglia, David Hinchliffe, Susan Jones, Michael Jordan, Mark Russo, Susan Salt and Gayle Snyder.

Elected to a one year term were Sondi Bachety, Andrew Cangemi, Eileen Darwin, Robert DeGregorio, Patricia Dillon, Joann Fsadni, Saul Fenchel, Joseph Garetano, Glenn Gordon, Stanley Lacher, Fran Pertusi, Jonathan Stone and Curtis Winkler.

Named officers of the Friends of Oheka were Edward J. Owen, president; Thomas Casey, Dinah Foglia, Dennis Garetano and Henry Zotti, vice presidents; Joan Cergol, secretary; and Linda Bay, treasurer.

Lady Airlie recalled her visit to the mansion as a young teenager. She had been with her mother, Margaret D. "Nin" Ryan, the youngest daughter of the Kahns. By that time, her grandmother Addie Kahn had sold the mansion. Ginnie said her mother was saddened that the house had fallen into such a state of disrepair. The tour ended with Gary Melius extending an invitation to Lady Airlie and her nephew to return at a future date to see the completed restoration. Friends of OHEKA continued to build support for Gary's restoration plans through the winter and throughout the following spring and summer. Finally, in October 1997, Friends of OHEKA learned that the town board had scheduled a public hearing on Gary's application for the adaptive reuses for the castle, including the banquet hall. (Courtesy of *Long Islander*.)

"The royal road to popular success is to demonstrate courage and independence and to stand up for one's convictions. Experience has shown that the greatest probability of scoring a hit is in aiming high."

- Excerpt from an address given by Otto H. Kahn in Washington, D.C. on May 16, 1924.

FRIENDS of OHEKA, Inc.

extends its sincerest thanks to the hundreds who came out at the September 24th Public Hearing to support the Historic Overlay District Legislation and its application to important historic buildings and sites in Huntington like OHEKA Castle.

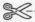 -

FRIENDS OF OHEKA MEMBERSHIP FORM

Complete and mail to: Friends of OHEKA, Inc., 135 West Gate Drive, Huntington, NY 11743 Attn: Joan Cergol

I support the mission of Friends of OHEKA, Inc. to preserve OHEKA Castle (Otto HErmann KAhn Mansion) to insure that it remains a viable and accessible treasure for the people of Huntington, our children and future generations.

NAME/S: _____

ADDRESS: _____

CITY, STATE ZIP: _____

TELEPHONE: _____

☐ I want to join in the effort to save OHEKA! Please add my name to your mailing list so I may receive the newsletter which will contain information about OHEKA Castle's history, as well as news of its progress, restoration and educational programs. Enclosed is my check for $10 payable to Friends of OHEKA, Inc. For more information call 367-2570.

Friends of OHEKA later received the following letter from Lady Airlie: "For me, it was a wonderful and curious experience as my mother had often talked of it. She referred to the house not as OHEKA but as Cold Spring Harbor. She used to tell us stories of her father commuting to Wall Street from his boat during the week. Sadly, my grandfather died when I was only one, so I never had the fun or excitement of knowing this remarkable and generous man. I did, however, see a good deal of my grandmother and went to school in New York. She possessed a rare intellect, had an immense humor like her father, and was a great golfer, linguist and lover of the arts. It was a rare treat for me to have had the opportunity of visiting the great house where my mother grew up and to find people so interested in helping to preserve a remarkable piece of history. Thank you—Ginnie." Shown here is an installment from OHEKA's 1996 newspaper advertising campaign. (Courtesy of Joan Cergol.)

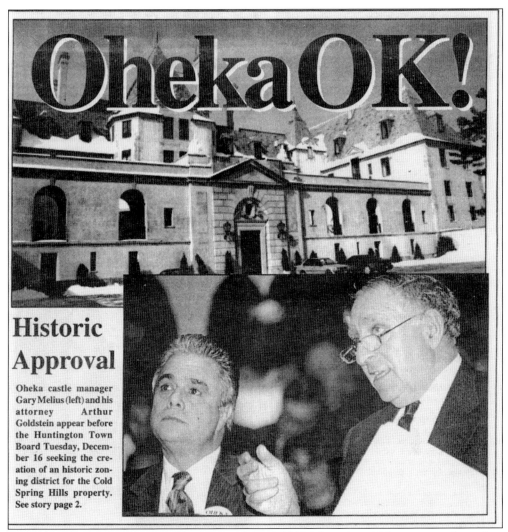

Oheka OK!

Historic Approval

Oheka castle manager Gary Melius (left) and his attorney Arthur Goldstein appear before the Huntington Town Board Tuesday, December 16 seeking the creation of an historic zoning district for the Cold Spring Hills property. See story page 2.

The hearing for OHEKA was held on December 16, 1997. More than 300 supporters showed up at Huntington Town Hall to support the mansion's application. Once again, it was standing room only. The first speaker that evening was Gary Melius's attorney, who presented the application to the town board. Then, a civic association member shared his views on the subject. He reminded the board that America is built on business and pointed out that if it takes a little American ingenuity to preserve one of the architectural treasures of this country, then surrounding residents can accept and participate in the changes taking place. He concluded, "Nothing remaining stagnant survives." The next speaker was the president of Friends of OHEKA who told the board that his organization stood united with the Cold Spring Hills Civic Association in strong support of the application. (Courtesy of *Huntington News*.)

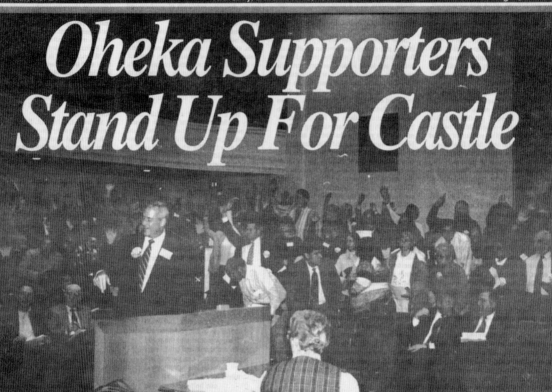

Oheka Supporters Stand Up For Castle

ed Owen, president of the Friends of Oheka, asks supporters of a permit application to stand up and be counted during Tuesday night's meeting of the Huntington Town Board. Th oard approved by a 5-0 vote the use of the facility as a banquet hall, designer's show house and luxury health spa.

Long-Islander Photo / Peter Slogga

More On Page 5

Town board members listened attentively as the testimony continued for more than two hours. Finally, at 10:15 that evening, the hearing was closed and the town board recessed to discuss the proposal in a closed-door, executive session. After an extended recess, the town board returned to the meeting room and the supervisor called for a vote on the application. The five-member board voted "aye," and the resolution granting the application was unanimously adopted. The simultaneous applause, cheers, and other loud exclamations of joy from the hundreds there to support the measure were deafening. For Gary Melius, the reality of what had occurred was just starting to settle in. He had finally won the town's blessing to forge ahead with the restoration of one of the largest and most majestic private homes in the United States. OHEKA Castle now had a future and a lot of friends to go with it. (Courtesy of *Long Islander*.)

Eight

MOVIES, TELEVISION, AND MORE

1941–PRESENT

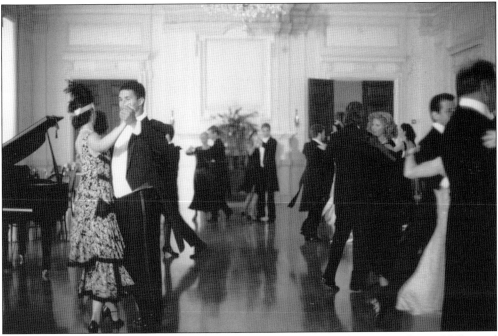

Since 1941, OHEKA Castle has attracted the interest of celebrities, television producers, Hollywood filmmakers, and photographers. National retailers have also used OHEKA as a dramatic backdrop for their promotions and catalogs. Shown here is a scene from the 1998 filming of Arts & Entertainment's (A&E) *America's Castles*. (Courtesy of Ellen Schaffer.)

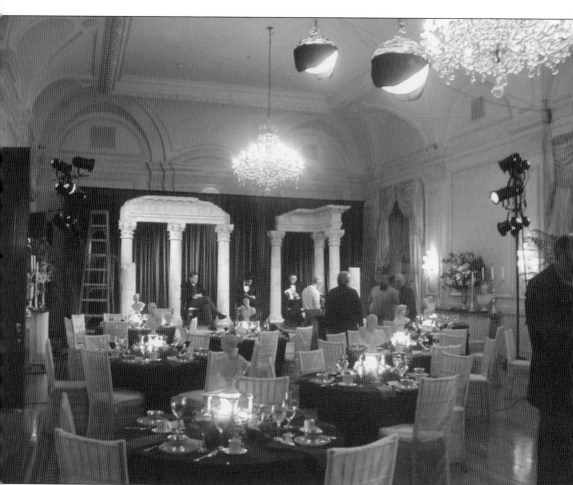

OHEKA Castle was featured in the A&E series *America's Castles* (1998) and was later in a segment of Home & Garden Television's (HGTV's) *Restore America* (2000), which referred to it as "the largest residential restoration in America." In 2004, OHEKA was listed in the National Register of Historic Places as the Otto H. Kahn Mansion. In 2011, it became a member of the Historic Hotels of America (National Trust for Historic Preservation). The mansion has also been the site of celebrity weddings, such as New York senator Alphonse D'Amato and wife Katuria (2004), 'N Sync's Joey Fatone and wife Kelly (2004), Long Island bestselling author Nelson DeMille and wife Sandy (2007), and Jonas brother Kevin and wife Danielle (2009). In 2009, OHEKA was named the "#1 Unforgettable Wedding Venue" by We TV Network. The filming of *The Emperor's Club* in the ballroom of OHEKA is pictured here. (Courtesy of Roger Diller.)

OHEKA made its film debut in 1941 when Orson Welles chose its exterior for the mysterious mountaintop castle of Charles Foster Kane in the movie classic *Citizen Kane*. Six decades later, studios returned to OHEKA for feature films such as *The Emperor's Club* (2002), starring Kevin Kline and Jesse Eisenberg, and *What Happens in Vegas* (2008), starring Cameron Diaz and Ashton Kutcher. OHEKA has also been discovered by network and cable television. In the photograph above, starring actor Kevin Kline and OHEKA staff member Tanya Kovacevic take a break during a long day of shooting the movie *The Emperor's Club* in 2002. Below, Cameron Diaz and Ashton Kutcher are pictured in a scene from *What Happens in Vegas*, 2008, filmed in OHEKA's terrace room. (Above, courtesy of Roger Diller; below, courtesy of OHEKA Castle Hotel & Estate.)

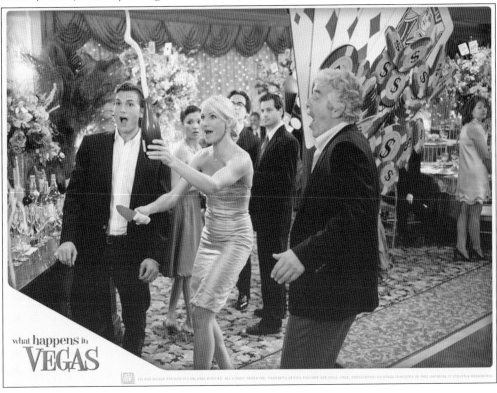

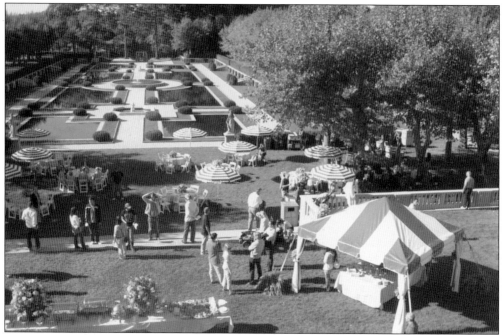

Pictured above and below are a daytime and evening scene from *What Happens in Vegas*, filmed at OHEKA Castle. The movie is about high-strung New York City stockbroker Joy Ellis McNally (Cameron Diaz), who gets dumped by her fiancé at a surprise birthday party she throws for him. At the same time, easy-going carpenter Jack Fuller (Ashton Kutcher) is fired from his job by his father, Jack Sr. (Treat Williams). Joy and Jack become emotionally distraught and, with best friends Tipper (Lake Bell), a bartender, and Hater (Rob Corddry), an attorney, take a debauched trip to Las Vegas. There, in a drunken state, the two marry. Later, they attend a business function (filmed in OHEKA's terrace room) where they come to realize they have true feelings for one another. (Courtesy of Roger Diller.)

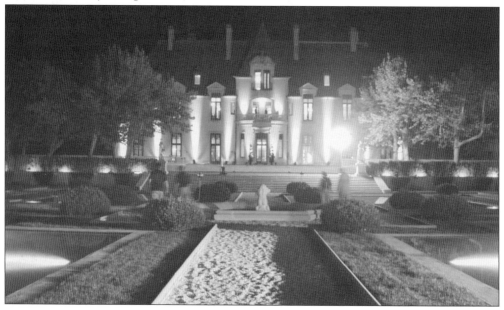

The USA Network television series *Royal Pains* portrays the mansion as the majestic estate of Boris Kuester von Jurgens-Ratenicz (played by Campbell Scott) and the residence of the show's main character, Dr. Hank Lawson (played by Mark Feuerstein). In the photograph at right, actor Mark Feuerstein is having fun on the set of *Royal Pains* in OHEKA's cobblestone courtyard. In the photograph below, the helicopter of Boris Kuester von Jurgens-Ratenicz lands in front of his Hamptons mansion, shot on location at OHEKA Castle. The actors and crew often stay overnight at OHEKA when filming scenes in and around the local Huntington area. (Right, courtesy of Nancy Melius; below, courtesy of Roger Diller.)

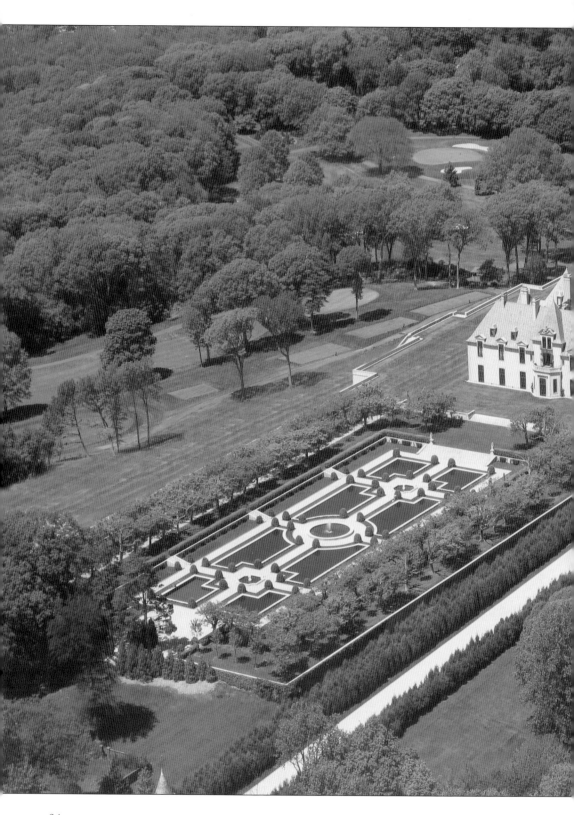

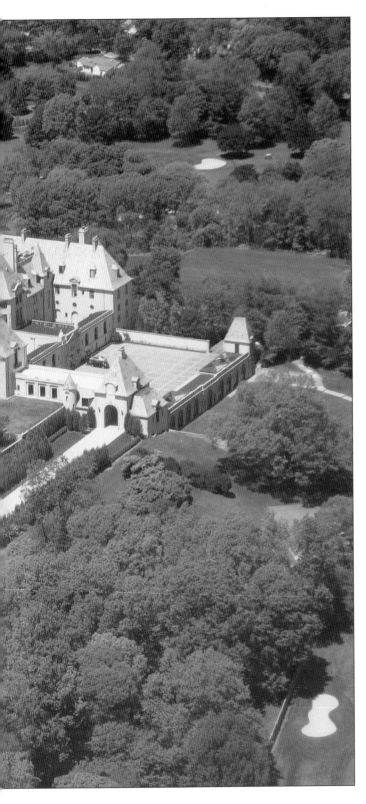

OHEKA has also been featured in the CBS television network show *A Gifted Man,* starring Patrick Wilson, Jennifer Ehle, and Margo Martindale. Among other cable network series, OHEKA can be seen on repeated airings of We TV's *Unforgettable Wedding Venues, Platinum Weddings,* and *Bridezilla.* Celebrities who have visited OHEKA include Alec Baldwin, Tony Bennett, Michael Bolton, Pres. Bill and Secretary of State Hillary Clinton, Sean Combs, David Copperfield, Geena Davis, Patrick Dempsey, Kenny G, Jake Gyllenhaal, Deborah Gibson, Steve Guttenberg, the Jonas brothers, Nicole Kidman, Heidi Klum, Lindsay Lohan, Jennifer Lopez, Ralph Macchio, Dolly Parton, Winona Ryder, Justin Timberlake, and Donald Trump. (Courtesy of OHEKA Castle Hotel & Estate.)

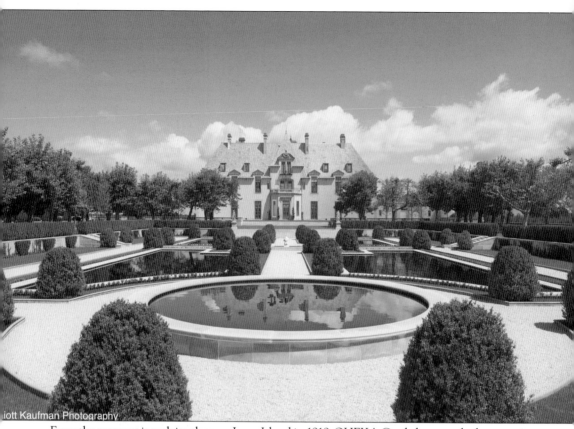

From the moment it took its place on Long Island in 1919, OHEKA Castle became the largest private home ever built in New York and the second largest in America. Overcoming insurmountable obstacles and near demise, it has become the largest restored home in America. Above all, this architectural treasure has resumed its place among America's most prominent and important historic buildings. The "crown jewel" of Long Island's Gold Coast mansions has indeed survived against unimaginable odds and, in doing so, has became a monument to survival for the world to see, to experience, and to love. Robert King, author of *Raising a Fallen Treasure* (1985), summed up the essence of OHEKA Castle's enduring legacy as follows: "Finally, it will stand as a living memorial to a man who not only had the means, but the vision and the determination to turn a white elephant, a losing battle and a fleeting remnant of our historical past into a successful, useful and purposeful structure to serve our modern-day society." (Courtesy of OHEKA Castle Hotel & Estate.)

Nine

HISTORIC PHOTOGRAPH MONTAGE
1897–1979

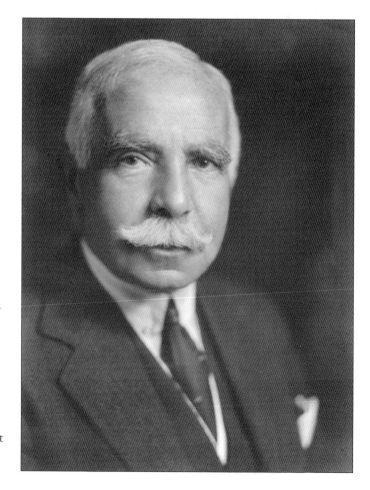

This closing chapter offers a recap of OHEKA Castle's history in never-before-published photographs taken from 1897 to 1979. This business portrait of Otto Kahn is among those that were shared by Kahn family members and others who photographed the mansion during its different incarnations. (Courtesy of Anne Baugh Minnehan.)

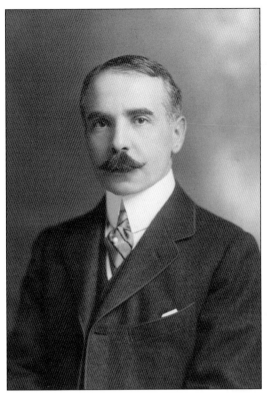

Otto Kahn (shown at left c. 1897 and below in later years) amassed his fortune as a partner in the Wall Street banking firm of Kuhn, Loeb & Co. He went on to become one of a handful of young bankers who, between 1897 and 1902, became Kuhn, Loeb & Co.'s third-generation partners. Interestingly, three other partners rose through the ranks of Kuhn, Loeb & Co. after marrying a founder's daughter. There was Mortimer L. Schiff, the only son of Jacob Schiff, who married one of the daughters of Solomon Loeb, a founder of the firm; Felix M. Warburg who wedded one of Schiff's daughters; and Felix Warburg's brother Paul, who married another of Loeb's daughters. (Both, courtesy of Anne Baugh Minnehan.)

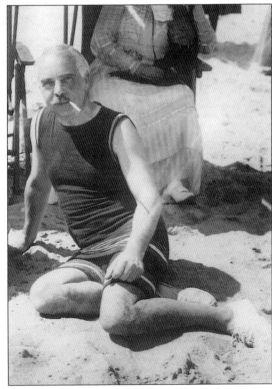

Kahn (shown at right and below in his usual style of impeccable dress) was the only partner admitted to Kuhn, Loeb & Co. who had not married one of the founders' daughters. Kahn, Mortimer Schiff, and the Warburg brothers all went on to succeed the firm's senior partner, Jacob Schiff, who led Kuhn, Loeb & Co. to rival J.P. Morgan & Co. as the leading investment bank in America. Recognized as an expert in international banking and railroad financing, Kahn was a key figure in the reorganization of the Union Pacific and other railroad companies. During his lifetime, Kahn served in many influential roles as director of dozens of investment firms, including the Equitable Trust Company of New York. (Both, courtesy of Anne Baugh Minnehan.)

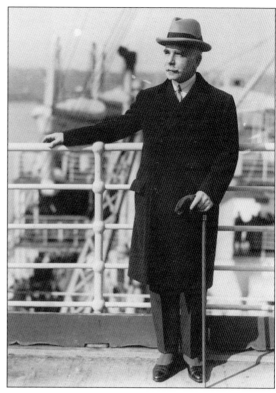

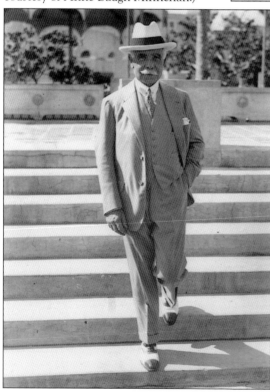

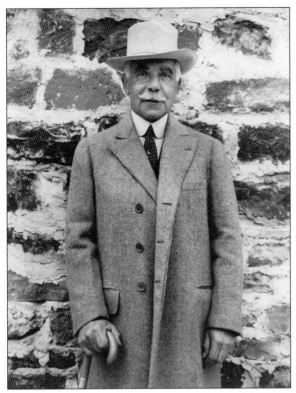

Kahn, at left, also held the post of chairman of the finance and currency committee of the New York Chamber of Commerce and as director of the National Economic League and its research corporation. He was further named honorable vice president of the Stable Money Association. An influential patron of the arts, Kahn was also involved in institutions of higher education and music. He was a trustee of the Massachusetts Institute of Technology (MIT), Rutgers College, and Carnegie Institute of Technology. He held a variety of other titles, including vice president of the Shakespeare Association in London. Below, Kahn is shown with his granddaughter Virginia, who in later years went on to serve as senior lady-in-waiting to the Queen of England. (Left, courtesy of Anne Baugh Minnehan; below, courtesy of Virginia Fortune Ogilvy.)

The elegant Addie Kahn, shown at right and below, was born in 1876 to a family of wealth, prestige, and culture. She was a woman of superior intellect, artistic talent, charm, and social grace. Addie met Kahn when he came to the United States in 1893 to take his place on Wall Street. His brilliance, continental demeanor, striking good looks, and reputation as a gentleman charmed young Addie. Then only 17, Addie was the daughter of Abraham Wolff, a senior partner at the banking firm Kuhn, Loeb & Co. After their marriage in 1896, Addie's father promised to reserve a desk for his new son-in-law upon the couple's return from a yearlong European honeymoon. (Right, courtesy of Anne Baugh Minnehan; below, courtesy of Virginia Fortune Ogilvy.)

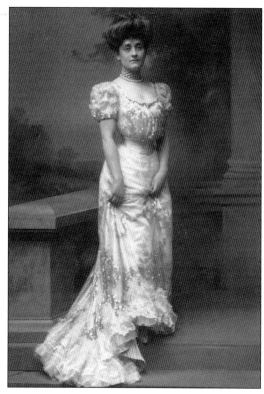

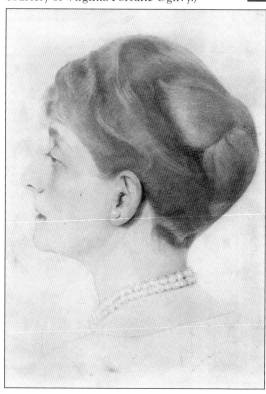

A gifted amateur landscape designer, Addie Kahn directed the development of landscaping at OHEKA, which was carried out by the famous Olmsted Brothers of Boston. When Olmsted brought in Beatrix Farrand to design the flower gardens, rose gardens, and amphitheater, Farrand reported directly to Addie. So pleased with the magnificent outcome of the formal gardens and reflecting pools, Addie saw to it that her private sitting room and master bedroom suite overlooked her work. Addie took great pride in using her Cold Spring Harbor mansion for social and business engagements, including full-scale dinner parties seating 200. Each guest would have his or her own personal valet for the affair. (Both, courtesy of Virginia Fortune Ogilvy.)

Shown here are the Kahns' two daughters, Maud Emily Wolff, born July 23, 1897, and Margaret (Nin) Dorothy Wolff born July 4, 1901. Both were born while the family resided at Cedar Court in New Jersey, which was later destroyed by fire. Margaret followed her father in joining the board of the Metropolitan Opera in 1956 after the company moved to Lincoln Center. She was also an art collector whose French Impressionist paintings hung in her triplex apartment in Manhattan's Upper East Side. In summers when Margaret went to London, her paintings were displayed in the Metropolitan Museum of Art. She was in her 20s when she met and married John Barry Ryan, who was working as a reporter for the *Newark Ledger*. (Above, courtesy of Anne Baugh Minnehan; right, courtesy of Virginia Fortune Ogilvy.)

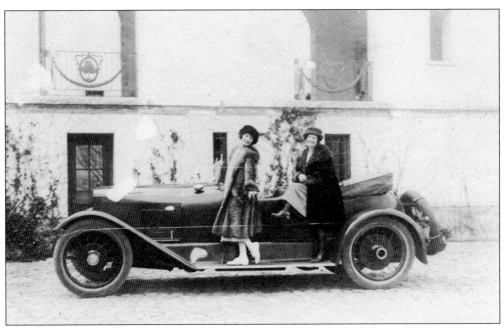

Maud and Margaret, above, moved into their summer home at Cold Spring Harbor at ages 20 and 16—old enough to enjoy many amenities of their parents' country estate. Maud was married at Cold Spring Harbor on June 15, 1920, to John Charles Oakes Marriott (later Gen. Sir John Marriott) of Great Britain. The wedding was considered a social news event—captured on newsreel and shown at New York's prominent Rialto Theatre. A special train brought guests from New York City to the ceremony at St. John's Church in Cold Spring Harbor. Another train brought additional guests directly to the reception. Maud's sister Margaret was the maid of honor. The bride is pictured below in the library. (Courtesy of Virginia Fortune Ogilvy.)

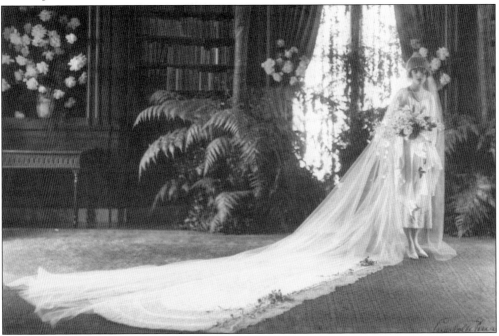

At right, Maud can be seen with her father, Otto Kahn. The *New York Times* reported that Maud's gown was made of a soft ivory satin with a long satin train edged with orange blossoms and trimmed with old rose point lace and studded with seed pearls. The only jewelry worn by the bride was a string of pearls given to her by her parents. At the time of their wedding, Marriott was the youngest officer of his rank in the British army. The following day, the couple, shown below, sailed to England so officer Marriott could rejoin his regiment. The bride served for three years in war service, both in France and England. Maud received the Medaille de la Reconnaissance from the French government. (Both, courtesy of Virginia Fortune Ogilvy.)

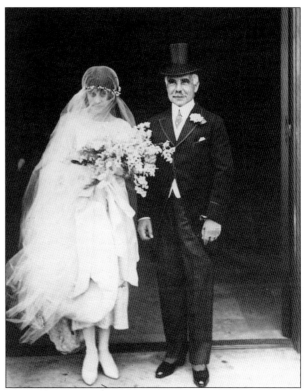

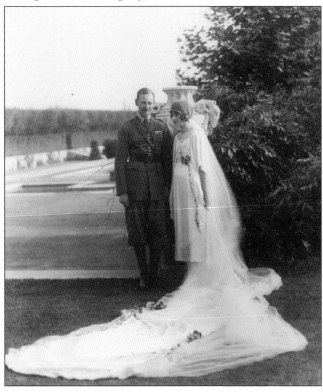

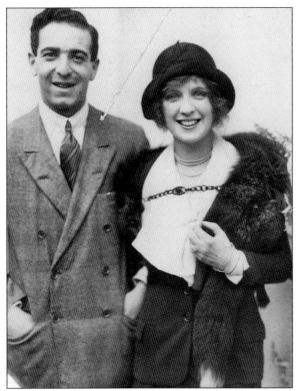

Shown at left with his first wife, Anne Elizabeth Whelan, is the Kahns' oldest son, Gilbert Wolff, born July 18, 1903. Following their divorce, Gilbert remarried in 1933 to Sara Jane Heliker, a Broadway dancer. He eventually followed his father to Kuhn, Loeb & Co., where he became a partner. The Kahns' younger son, Roger Wolff, shown below, was born on October 19, 1907. Roger was a test pilot for Grumman, but as a young adult led his own band and was well known in New York City jazz circles. He was nicknamed "Pips" and was known to bribe the night watchman at Cold Spring Harbor to slip off and play in his jazz band. An enthusiastic aviator, Roger flew acrobatics over the mansion before landing on a private strip his father built for him. (Both, courtesy of Anne Baugh Minnehan.)

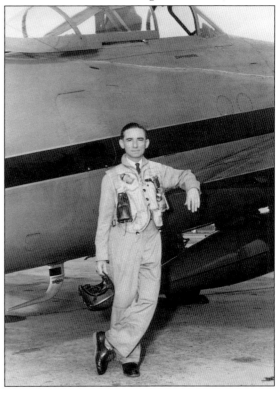

Depicted above on March 15, 1928, Otto Kahn leaves Fort Worth, Texas, with his family for California. Below, the Kahns' 1100 Fifth Avenue mansion was completed in 1918, just one year earlier than their Cold Spring Harbor country estate. Located at a prominent site on Manhattan's Upper East Side, the sprawling townhouse served as the Kahns' primary residence. It was also constructed to showcase their extensive art collection. The Roman Revival mansion spanned an entire city block. Kahn purchased the site from Andrew Carnegie, whose own mansion, directly across Ninety-first Street, later became the Cooper Hewitt Museum. (Above, courtesy of Anne Baugh Minnehan; below, courtesy of OHEKA Castle Hotel & Estate.)

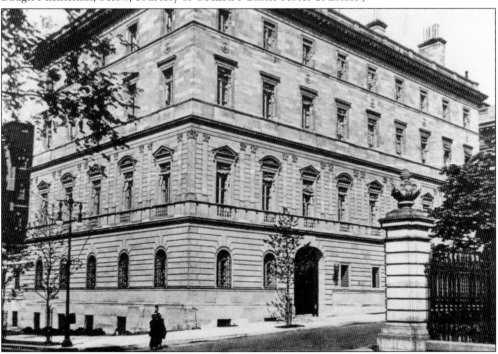

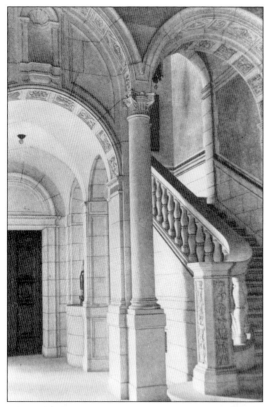

The Kahns' New York City residence, shown here, featured ornate coffered ceilings, grand stone fireplaces, and a Renaissance courtyard with a stone balustrade overlooking Central Park. There was also a private enclosed drive that afforded arriving guests convenience and privacy. A second-floor music room was used as a recital hall for private performances by opera legend Enrico Caruso. Below, the Kahns are pictured in their New York City library with Rembrandt's *Head of a Young Student* over the fireplace. The Kahns' art collection came to be known as the finest in the United States. A priceless Byzantine Madonna can still be found in the reception room of the Kahns' former mansion, today the Convent of the Sisters of the Sacred Heart School. (Courtesy of OHEKA Castle Hotel & Estate.)

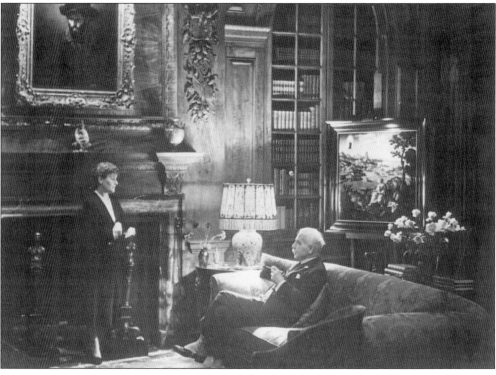

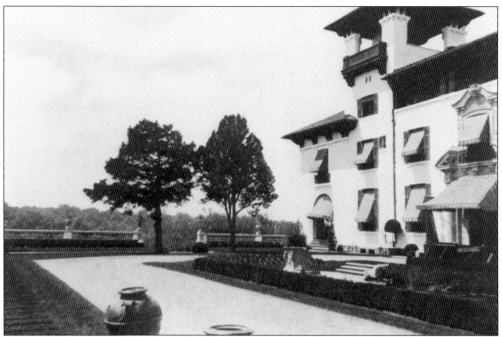

Cedar Court is shown above and below. The home was commissioned by Addie's father, Abraham Wolff, and was constructed on a 260-acre tract of land. Kahn later replaced this home with a two-story Palladian pergola villa after fire destroyed most of the original residence. It was this loss that later motivated Kahn to protect what remained of his precious collection of art and antiques by using fireproof materials in his future homes. Cedar Court was later demolished, and the estate land was eventually sold to Allied Chemical & Dye Corporation for its worldwide headquarters. (Both, courtesy of OHEKA Castle Hotel & Estate.)

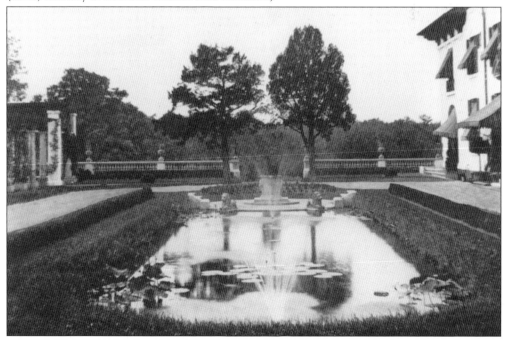

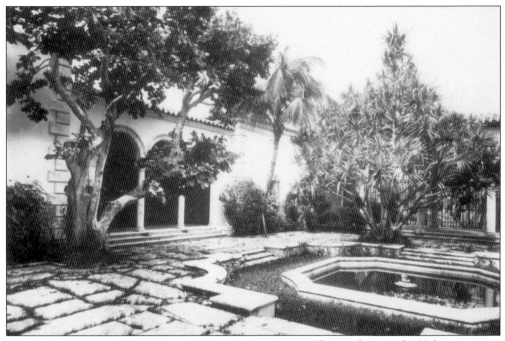

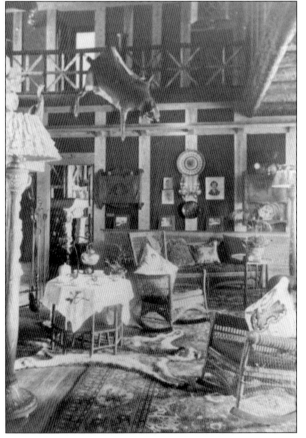

Shown above is the Kahns' villa in Palm Beach, Florida. When the family outgrew that residence, Kahn built a larger home in a similar Renaissance style for $250,000 in a nearby Florida community. That home later became the Graham-Eckes School and has since been declared a historic landmark. Shown at left is the Kahns' lodge in Upper Saranac Lake in the Adirondack Mountains, New York. "Otto Kahn Camp" was one of the first lodges to be built in the Adirondack Park region prior to 1920. The Kahns used Kahn Camp as a retreat from the hustle and bustle of the city prior to the construction of their Cold Spring Harbor residence. (Both, courtesy of OHEKA Castle Hotel & Estate.)

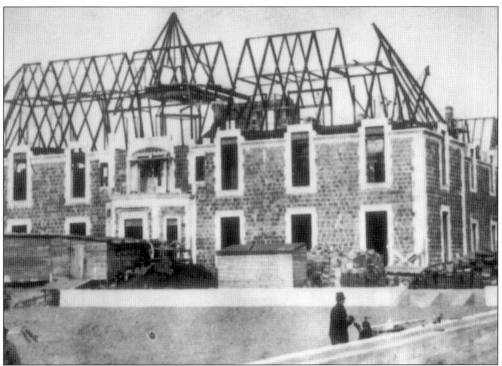

Shown here in 1917, construction of the mansion began under the expertise of Delano & Aldrich of New York City. Delano & Aldrich's design of country houses was prolific and included more than 30 commissions on the North Shore. Their clients included such heavy hitters as Astor, Burden, Havemeyer, Lindbergh, Pratt, Rockefeller, Vanderbilt, and Whitney. The firm's work ranked among the best of its time, and while it had commissions across the country, a majority of its clients were in New York and selected the Gold Coast of Long Island as the site for their summer homes. By 1935, it had taken on 243 individual commissions, 111 of which were country homes. Of the country homes, 32 were located on Long Island. OHEKA was by far the largest country home in their portfolio. (Both, courtesy of OHEKA Castle Hotel & Estate.)

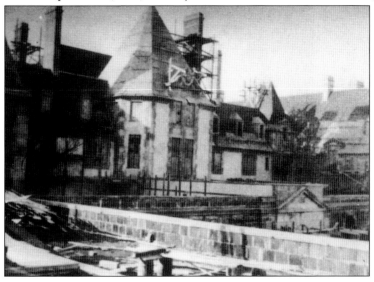

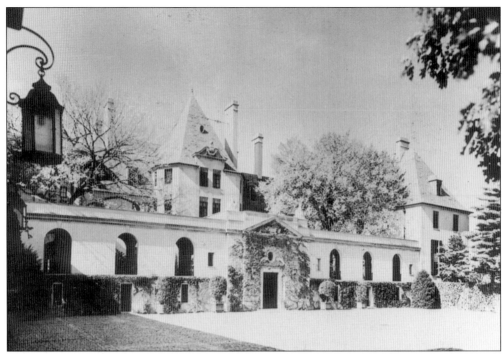

Shown above is the front facade of Cold Spring Harbor. Inside, in Otto's dressing room, drawers were built into the walls containing a front cut-down, which formed a decorative but convenient handhold. Each drawer was labeled for his butler's convenience with titles such as "the master's blue shirts" or the "master's golf shirts." Closets were built into the walls in the same motif, each marked with its contents. Otto and Addie shared a sitting room with an outdoor terrace that overlooked their impeccably maintained formal gardens. The four Kahn children possessed separate bedroom suites with an adjoining sitting room, dressing room, and bathroom. Shown below is the first of three gatehouses. (Both, courtesy of OHEKA Castle Hotel & Estate.)

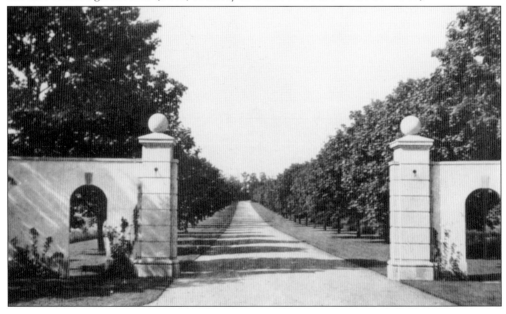

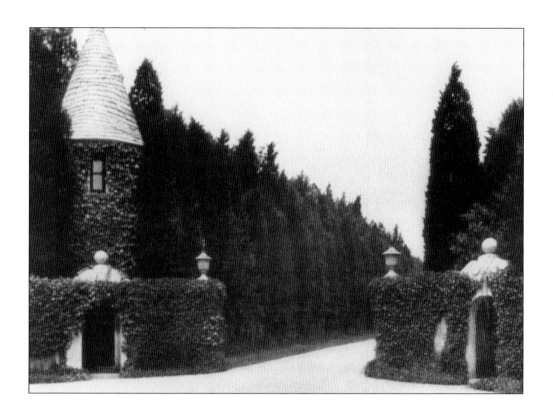

Above, the second gatehouse welcomed visitors through the estate's main drive called West Gate. A service drive to the east, known as East Gate, ran parallel to the main drive past the clubhouse and stables where it connected to the mansion at the servants' wing. Below is *OHEKA II*, Kahn's largest yacht. It was a 73-foot Maybach express cruiser that Kahn purchased for $90,000. The vessel required a crew of six and could dine and bunk 12 guests. Powered by three 550-horsepower Maybach engines, *OHEKA II* could reach a speed of 34 knots, making it the world's fastest boat in its class. Kahn used it to travel back and forth to New York City when in residence at his Cold Spring Harbor estate. (Both, courtesy of OHEKA Castle Hotel & Estate.)

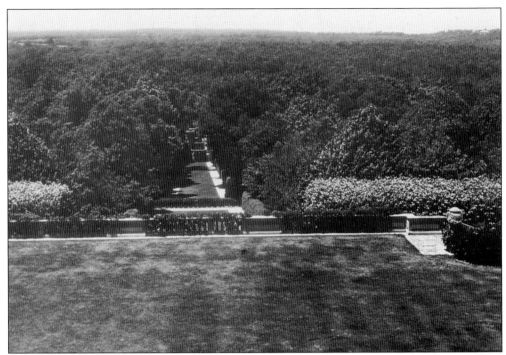

Shown here are Addie Kahn's "ruins." It was customary for large estates to feature such structures for the lady of the house, where she could visit and meditate during her leisure. The structure also served as a fountain where water cascaded from the top down to the ground below. The ruins are located to the north of the mansion on a straight line from the ballroom's center double doors. The Kahns' landscape architectural firm, Olmsted Brothers, brought in Beatrix Farrand in 1919. Farrand (1872–1959), a noted landscape architect, was the only woman of the 11 founders of the American Society of Landscape Architects. (Both, courtesy of Madeline Fox.)

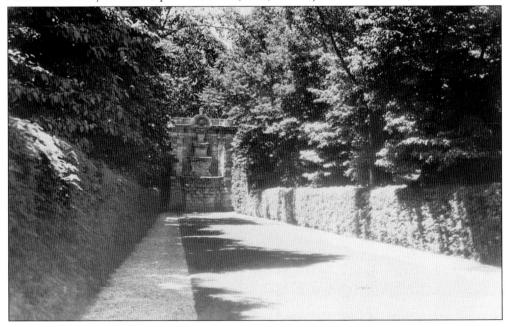

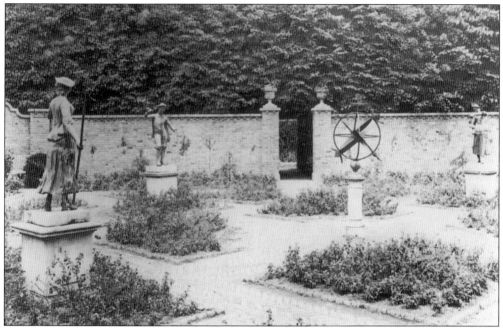

Beatrix Farrand began practicing landscape design in New York City at the age of 25. Farrand was the innovator of garden rooms, which became a hallmark of modern landscape architecture. Her initial designs were for the neighbors of her Bar Harbor, Maine, residence, but she eventually designed for J.P. Morgan, John D. Rockefeller, and Theodore Roosevelt. Farrand was Princeton University's first consulting landscape architect; she served in that capacity from 1912 to 1943. During that time, she designed landscaping at a dozen other campuses, including Yale and the University of Chicago. Shown here are gardens, statuary, and walking paths in OHEKA's formal gardens. (Both, courtesy of Long Island Studies Institute.)

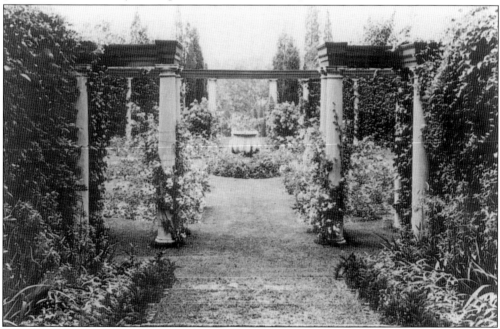

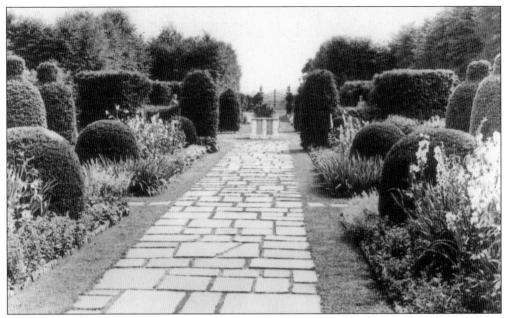

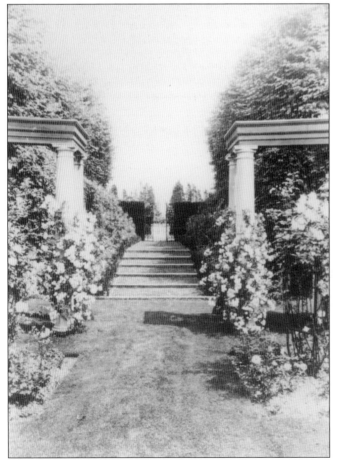

Farrand drafted planting designs for the White House and designed the Morgan Library grounds in New York; the Huntington Library grounds in San Marino, California; and the Santa Barbara Botanic Garden in California. The gardens and amphitheater at Cold Spring Harbor, designed by Farrand between 1919 and 1928, were eventually lost. Fortunately, landscape photographer Mattie Edwards Hewitt extensively documented the gardens shortly after they were completed. The Kahns' gardens reflected a unique collaboration between Delano & Aldrich and the Olmsted Brothers, with strict oversight by Addie Kahn. Most of the work was completed after the Kahns were in residence at Cold Spring Harbor. In this way, Addie could be on site and directly involved. Shown here are two walking paths. (Both, courtesy of Long Island Studies Institute.)

These photographs depict OHEKA during its years as Sanita and the Kahn Station, between 1939 and 1945. The photographs were given to Gary Melius by Madeline Fox, whose family purchased the Kahn estate from the City of New York in April 1940. Few images exist from this period. In June 1939, the Kahn estate was sold to the Welfare Fund of the New York City Department of Sanitation and was renamed Sanita. Negotiations for the sale were handled between Addie Kahn and William F. Carey, sanitation commissioner. The price was $100,000, a small fraction of what it cost to build and just four times the annual property taxes. Since the Kahn family held the mortgage, no money actually changed hands. On July 9, 1939, Sanita guests are shown here enjoying their day. (Both, courtesy of Madeline Fox.)

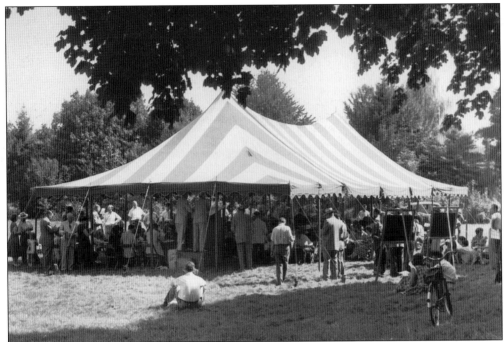

Soon after the sale was announced, rumors spread throughout Huntington that the transaction was nothing more than a tax-dodging scheme on the part of the Kahn family to avoid the property taxes. Both the local South Huntington School District and the Cold Spring Harbor Fire District were quick to express their dissatisfaction with the property being removed from the assessment rolls. The tax contribution of the estate represented one eighth of the budgets of the school and fire districts. Removing the property from the tax rolls would mean that other landowners in the districts would shoulder a larger tax burden. Depicted here, Sanita visitors enjoy lunch under a large tent and on the grounds of the former Kahn estate. (Both, courtesy of Madeline Fox.)

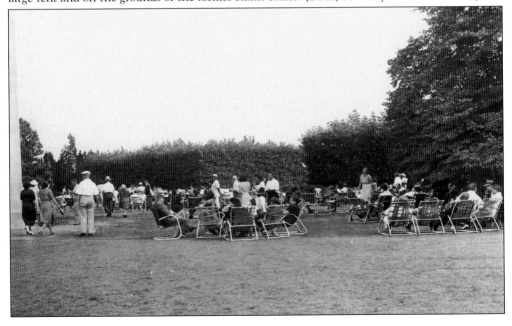

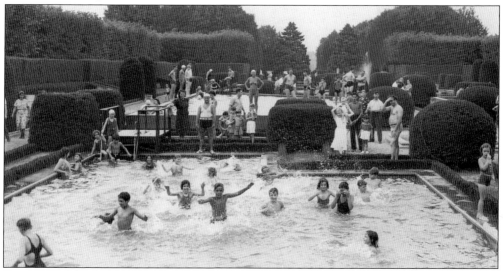

Fearing an unwanted increase in their own tax bills, local residents began voicing their objections to the Town of Huntington. A petition protesting any tax-exempt status for the Kahn property was circulated by the school district. But even as the opposition mounted, work to transform the mansion into the new Sanita recreational center had begun. The sanitation department was installing dozens of additional toilets inside the mansion. The department had not bothered to obtain any building permits from the town, and the work appeared to be in clear violation of local ordinances. Meanwhile, the Kahns' reflecting pools were being transformed into swimming pools for visitors to enjoy, as shown here. (Both, courtesy of Madeline Fox.)

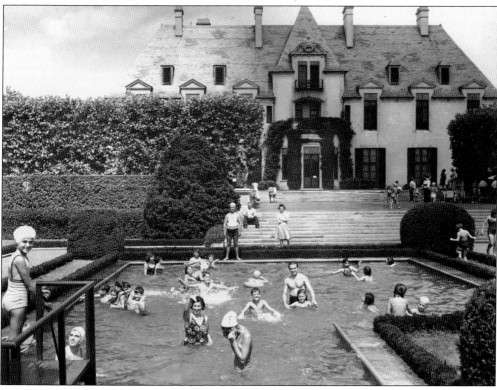

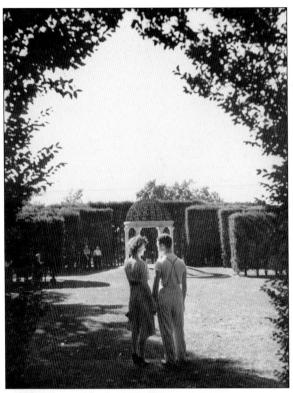

In the weeks prior to Sanita's opening, Mrs. Carey, wife of the commissioner, spent much of her time shopping for furnishings. She decided to adorn the house with antiques to resemble the decor of the Kahns. "No modern equipment would be used," she announced. She had shopped furiously for scores of beds, dressers, night tables, and chairs. Mrs. Carey proclaimed, "The best mattresses money can buy would be purchased for all of the beds." She visited secondhand stores and picked up the *Complete Works of Edgar Allen Poe*, *Compton's Picture Encyclopedia*, and the *Memoirs of Jacques Casanova* as well as other works she felt would appeal to sanitation employees. A young couple at Sanita appears at left, while the Sanita band entertains the crowd below. (Both, courtesy of Madeline Fox.)

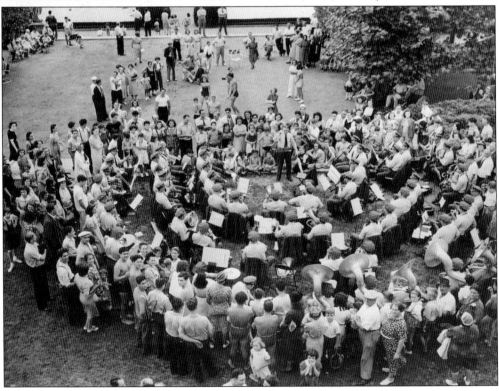

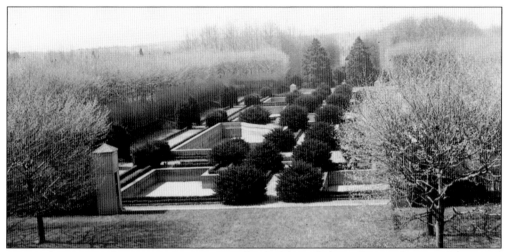

In March 1943, Realty Associates announced it had leased the Kahn mansion to the United States War Shipping Administration for use as a school for maritime radio operators. The rent was reportedly $1 a year. The trainees and staff started arriving just two weeks after the lease agreement was announced. Not a word of opposition came from the local citizenry in Cold Spring Harbor or the local officials at Huntington Town Hall. America was at war, and the Kahn mansion would be used in the war effort. Tax-exempt status or not, this use was one which the neighbors and politicians would proudly support. In the photograph above, the Sanita swimming pools have been emptied. Below, the Kahn Station cadets are learning code in the ballroom. (Above, courtesy of Samuel Pearsall; below, courtesy of Madeline Fox.)

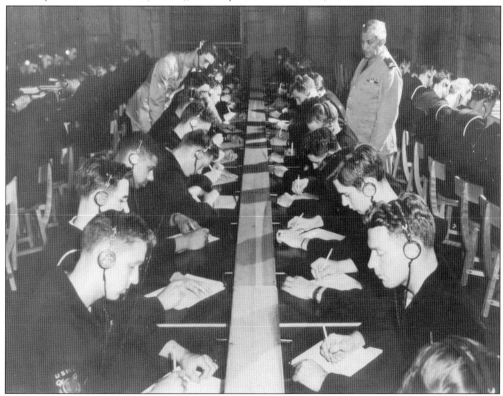

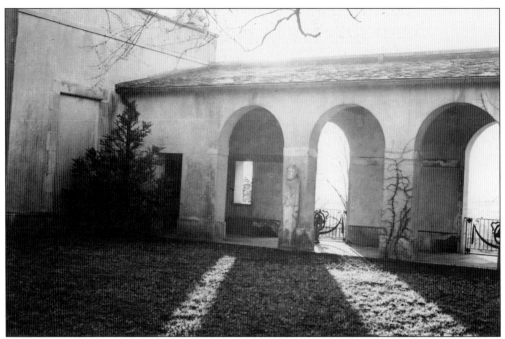

Before the trainees arrived, the mansion was transformed into a radio school with modern equipment. The ballroom was the main code room. False wooden floors covered the estimated 6,500 feet of cable and wire run underneath. Dozens of tables were lined up in rows from one end of the room to the other on which hundreds of receiving headsets were mounted. Otto Kahn's library was the typing room and served as another code room. The formal dining room was set up cafeteria style for a mess hall. Kahn's mahogany-paneled study and the billiards room were used as classrooms. Shown are one of the interior courtyards overlooking the cobblestone courtyard (above) and the tennis courts, below, where the cadets enjoyed recreation time. (Above, courtesy of Samuel Pearsall; below, courtesy of Frank A. Jenne.)

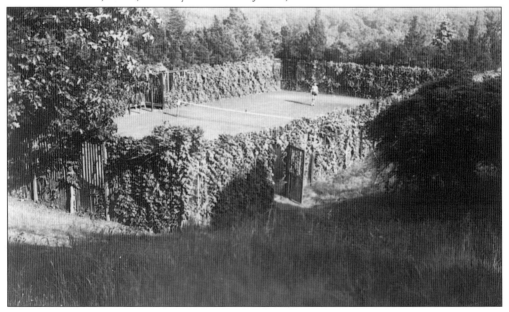

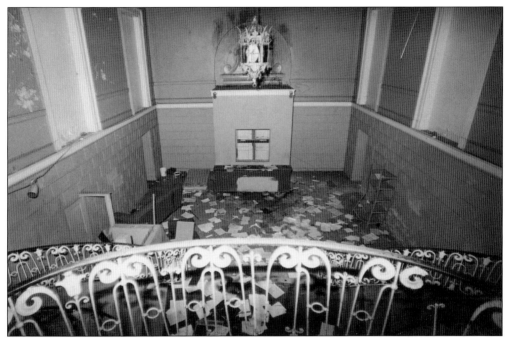

The next and final series of photographs were taken by Shari Nocks Gladstone, who was hired in 1979 to document the deplorable conditions of the mansion at that time following its use as Eastern Military Academy for 30 years, from 1948 to 1979. Reminiscing about her impressions of the castle in later years, Gladstone said, "It was horrible. Rooms that once were elegant were now covered with graffiti—filthy words, hate slogans, revolutionary buzz words—painted in black and blood red, as well as distorted and graphic sexual depictions. Elegant ceilings and moldings had been destroyed. Most of the rooms were filled with trash." The photograph above shows the view from the top of the grand staircase looking toward the front door. Below is the ballroom, as Gladstone observed them that day. (Both, courtesy of Shari Nocks Gladstone.)

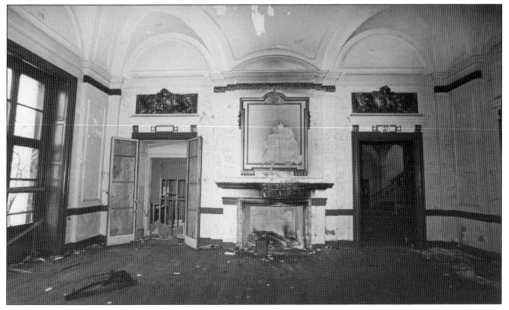

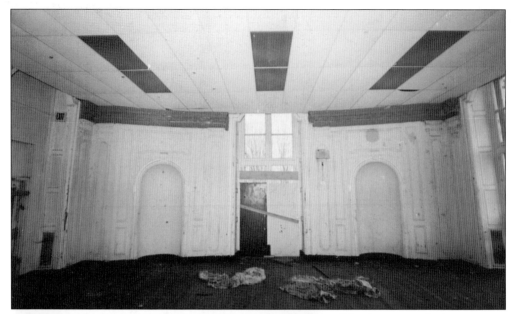

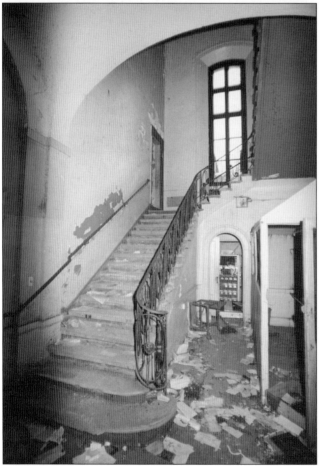

The damage to the immense mansion was evident even from a distance. The once manicured gardens and sprawling lawns were overgrown and filled with brown grass and weeds that stood two feet tall. The building itself had been defaced with red, yellow, and blue paint. The grounds surrounding the mansion were littered with debris, broken furniture, clothing, books, papers, broken glass, smashed slate roof tiles, and innumerable empty beer cans. It had been years since the trees and shrubs on the property had been pruned, and it seemed that each tree had broken branches and every bush was overgrown. Shown are the dining room with its dropped ceilings installed by Eastern Military Academy (above) and a staircase (left) from the main level to the mezzanine. (Both, courtesy of Shari Nocks Gladstone.)

Getting upstairs to the second floor was made difficult by overturned furniture, filing cabinets, and other junk that littered the staircases. Damage from vandalism, fires, and rain that had poured through broken windows was clearly visible. Handcrafted ceilings and valuable wood floors had been destroyed over the years. It appeared that as many as 10 layers of paint had been applied to interior walls, much of it now peeling off, adding to the layers of assorted materials littering the floor. Much of the interior had been painted in the same military blue—even the ceramic tiles on the bathroom walls. At right is a staircase to a mezzanine level. Below is a ransacked room. (Both, courtesy of Shari Nocks Gladstone.)

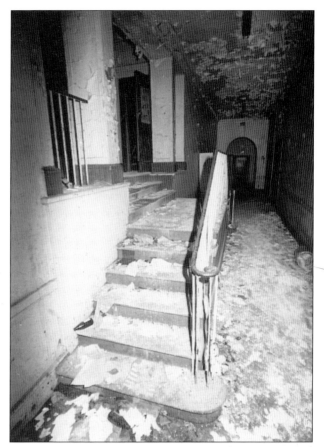

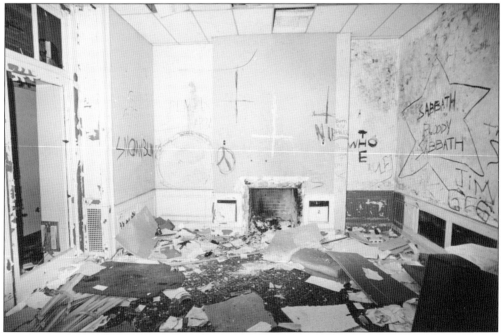

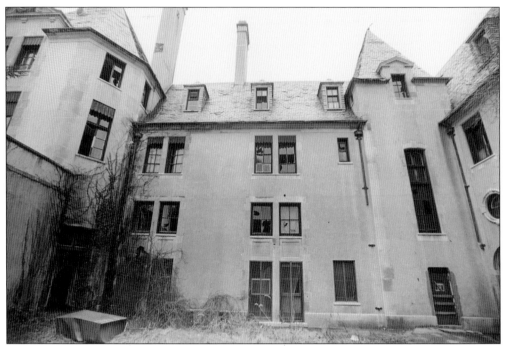

Some rooms contained charred debris, while in others burned wood floors were visible beneath the rubble. There was a faint acrid odor inside the building. Every room was stripped of its fixtures. Switch plates, door handles, ceiling fixtures, and sconces were missing. In the bathrooms, copper pipes had been ripped out of the walls. Some of the vandalism and graffiti left behind expressed antiwar sentiments. Shown above is the west side of the mansion where the Addie Kahn sitting room is located. Below is the second gatehouse completely overgrown with ivy. (Above, courtesy of Shari Nocks Gladstone; below, courtesy of OHEKA Castle Hotel & Estate.)

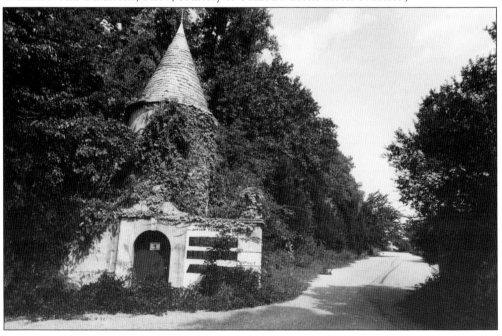

BIBLIOGRAPHY

Caro, Robert A. *The Power Broker: Robert Moses and the Fall of New York*. Alfred A. Knopf, 1974.

King, Robert B. *Raising a Fallen Treasure: The Otto H. Kahn Home, Huntington, Long Island*. New York: The Mad Printers of Mattituck, 1985.

Kobler, John. *Otto the Magnificent, The Life Of Otto Kahn*. New York: Charles Scribner's Sons, 1988.

Matz, Mary Jane. *The Many Lives of Otto Kahn*. New York: The Macmillan Company, 1963.

Zaitzevsky, Cynthia. *Long Island Landscapes and the Women Who Designed Them*. New York: W.W. Norton & Company, 2009.

"Consider Tearing Down Kahn Mansion, Escaping High Taxes." *Long Islander*, April 27, 1939.

"Some 20,000 Members Enjoy Liberties of Large Kahn Estate." *Long Islander*, July 13, 1939.

"The Board Authorizes Court Action on Kahn Estate Matter." *Long Islander*, July 20, 1939.

"Judge Dodd Grants Injunction Against Sanita Lodge Crowd." *Long Islander*, January 4, 1940.

"Mayor LaGuardia and Town Board Meet; Sanita Lodge Is Ended Here." *Long Islander*, March 7, 1940.

"Radio Men To Train At Otto Kahn Estate." *New York Times*, March 15, 1943.

"U.S. Maritime Service Has Leased Part of Otto H. Kahn Estate." *Long Islander*, March 18, 1943.

"Former Kahn Home To Be Boys' School." *New York Times*, August 17, 1948.

"Memories of OHEKA Castle and Eastern Military Academy." Roger Hall, 2004.

The oral histories, as recorded by the authors, of Claire Kahn Baugh, Rosemary Dunning Commander, Roger Hall, Gary Melius, Shari Nocks Gladstone, Samuel Pearsall, Frank L. Scalia, and Marion Weithorn were also consulted during the research of this book.

DISCOVER THOUSANDS OF LOCAL HISTORY BOOKS
FEATURING MILLIONS OF VINTAGE IMAGES

Arcadia Publishing, the leading local history publisher in the United States, is committed to making history accessible and meaningful through publishing books that celebrate and preserve the heritage of America's people and places.

Find more books like this at
www.arcadiapublishing.com

Search for your hometown history, your old stomping grounds, and even your favorite sports team.